THE ENCYCLOPEDIA OF FLOWER-PAINTING TECHNIQUES

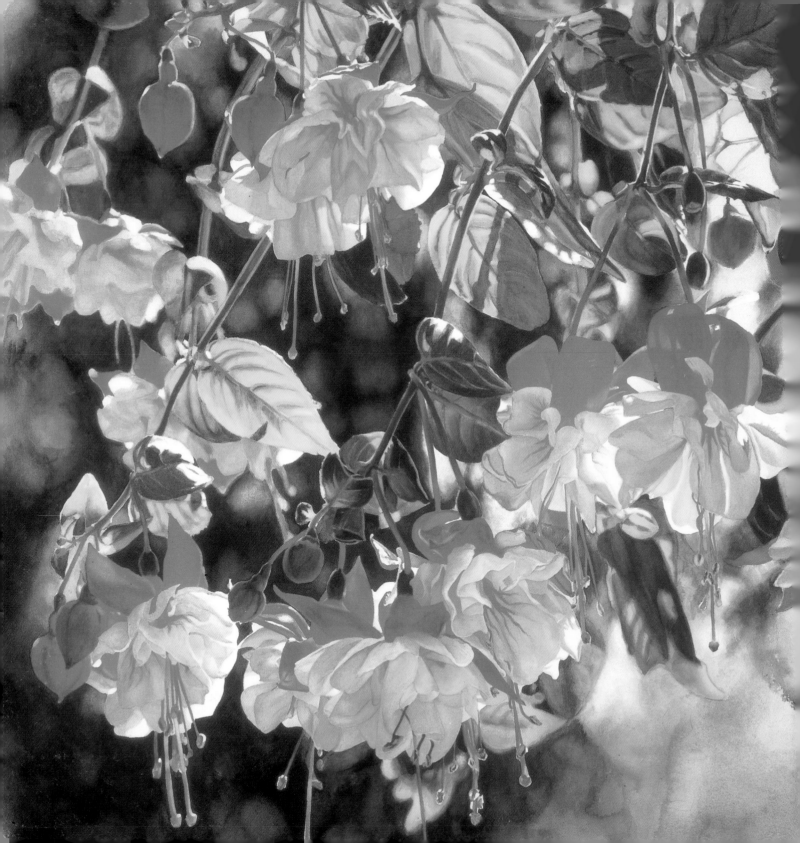

THE ENCYCLOPEDIA OF FLOWER PAINTING TECHNIQUES

Sue Burton

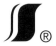

Sterling Publishing Co., Inc.
New York
A Sterling/Silver Book

Conceived, designed, and produced by
Quarto Publishing plc
The Old Brewery
6 Blundell Street
London N7 9BH

10 9 8 7 6 5 4 3 2 1

Published in 2003 by
Sterling Publishing Co., Inc
387 Park Avenue South
New York
NY 10016-8810

QUAR.FHO

Distributed in Canada by
Sterling Publishing
c/o Canadian Manda Group
One Atlantic Avenue, Suite 105
Toronto, Ontario, Canada M6K 3E7

Typeset by Central Southern
Typesetters, Eastbourne
Manufactured in Singapore by Pica
Colour Separation Overseas (Pte) Ltd
Printed in China by Leefung-Asco
Printers Ltd

ISBN 1-4027-0395-3

► TWO KISLET IRISES
Nedra Tornay
Watercolour
Glowing colours illuminated by
sunlight, casting complicated
shadows, provide the ultimate
challenge when the beauty of
a flower is unfolding in front
of you. This watercolour of
irises epitomizes the intricacies
of the art handled by a
professional.

Contents

INTRODUCTION

Just think of the word "flowers," and images start to flow into your mind: a garden in summer, a vase of flowers catching the light from a window, or a bouquet from a friend can inspire you with color, atmosphere, and even nostalgia.

For the beginner, flowers and their foliage provide an endless source of subject matter to practice on in any medium, even if you do not intend to specialize in them. From wild flowers to exotic, cultivated varieties, there is always something to paint, even in the dead of winter. They are also a good subject for the disabled or those who are housebound.

This book provides a starting point for tackling the subject, whatever your aspirations. If you have never drawn a flower before, the following chapters will show you how to start. The first section is devoted to paints and how to exploit their characteristics, the tools for applying them, and how the surfaces of differing grounds will affect the results. The next section provides food for thought on how to arrange your subject and how to care for it, thus allowing you to finish your work before buds open or flowers die. The exercises help you to sort out which techniques to employ, and give you an insight into analyzing the shapes. The penultimate chapter allows you to look over the shoulder of experienced artists, as they illustrate step-by-step the way they sort out their priorities. Finally, Themes is a collection of work from renowned artists worldwide.

Flowers have been symbolic through the ages: life and death, the seasons, and your emotions can all be depicted through flowers. Artists use flowers and leaves for the message they can give, telling a story, or sending a wish to a friend. For example, ivy is a fairly universal symbol for friendship or fidelity, and a red rose has the obvious implications of love. During the Renaissance, Mary, the mother of Jesus, was invariably painted with a white lily, the symbol of purity—this gave rise to the name, Madonna lily.

THE HISTORY OF FLOWER PAINTING From the earliest times, artists have sought to capture the delicate and emotive designs of nature, as can be seen on pottery and jewelry found by archeologists. A knowledge of herbs was vital to healers. The first dated examples of such "Herbals" come from the Greeks and the Romans, and the oldest complete Herbal is the Codex of Dioscorides, which dates from AD 512, and was made on vellum.

THE GREAT ARTISTS Most great artists have depicted flowers in some form or other. In the seventeenth and eighteenth centuries, Dutch painters were renowned for their rich, glowing flower portraits. These depicted wonderfully elaborate arrangements, with meticulous attention given to a shining dewdrop or a snail, added to give emphasis to the composition. The fact that all the flowers in one painting could not have been in season at the same time does not seem to have mattered—perhaps the artists painted in each flower as it appeared through the seasons. The rich colors and gorgeous displays gave the Dutch pride of place in the flower-painting world, and this work is well represented in many major collections.

Flower paintings still set the pace in money markets today. Van Gogh's *Irises* set a record in the art world in 1987 when it was sold by Sotheby's in New York for over $30 million. It was then bought by the Getty Museum for somewhere between $35 and 60 million, making it one of the most expensive paintings sold in the twentieth century. Van Gogh's painting *Sunflowers* is also in the same monetary league.

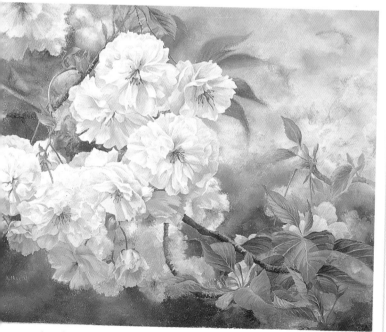

A soft pastel background lifts this cherry blossom painted in gouache. Dark stems and touches of pink and green help to restore focus, keeping the painting vibrant.

For hundreds of years, gardens have been the record of man's ambition to create a place of order or peaceful retreat. The Islamic courtyard was an oasis from the desert, and the sixteenth-century gardens in Florence, Italy, reveled in formal geometric shapes, which were then brought to a peak in such amazing places as Versailles in the reign of Louis XIV of France (1638–1715). The demand for designs and examples of new plants to bring these ideas to life increased dramatically and coincided with the beginning of the age of the great explorers, when many Europeans brought back a great variety of plants from their travels. They took artists with them on their expeditions, and cataloging these new and exciting specimens played a part in the rise to fame of some of the master artists of the eighteenth and nineteenth centuries.

Possibly the most famous of these, Pierre-Joseph Redouté (1759–1840), was a prolific illustrator of plants, with over 1,800 examples. He is most famous for painting a large collection of roses, which have helped trace the ancestry of many old varieties. Although strictly speaking he was a botanist, he managed to combine the decorative and the useful. Redouté's work has influenced many artists, from textile design to porcelain, and most of us have seen reproductions of his paintings.

Later came the intrepid explorer-artists who left a wonderful legacy to the world. The Englishwoman Marianne North (1830–90) did not really begin her career until she was 40, when she received an invitation to visit America, which was the first of her many trips around the world. The gallery at the Royal Botanic Gardens, Kew, specially built to house all her work, contains 848 paintings and is a unique historical record. Margaret Mee (1909–88) went to live in South America in the 1950s. She completed 15 Amazon journeys and discovered several new plants, some of which were named after her. Like Marianne North, she painted in some of the remotest parts of the world, giving us the most magnificent record of flora and fauna, some of which are rare plant species that have been lost forever as their natural habitats have been destroyed.

BOTANICAL ARTISTS Botanical artists illustrate how a plant is structured and how it grows, which requires scientifically correct, black-and-white drawings on a pure white background, shown without sentiment. Although cross-sections of seeds, hairy stems, and studies of root systems may not be everyone's idea of the perfect picture to hang in the house, it is worth making some study of the basic construction of a plant and its environment.

Whether you only want to revel in the colors and shapes of flowers, or have ambitions to win a Gold Medal at the Royal Horticultural Society Exhibitions in London, or be chosen to show at the Hunt Institute in Pittsburgh, this book will help you

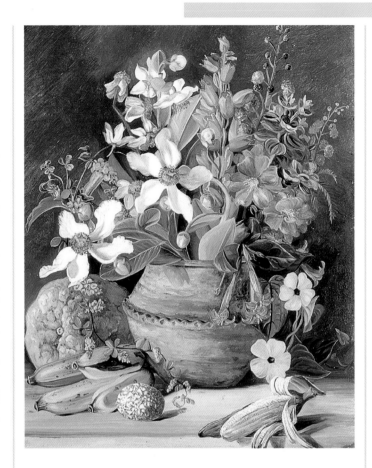

A group of "wild meadow flowers" from Brazil by Marianne North.

to experiment with different approaches. How much detail should you include, or conversely, how can you leave details out and still get to grips with a complicated mass of shape and color? Which medium should you use? How do you match the brilliant pure colors of the flowers you see? From gentle transparent watercolors to the huge, vibrant, and dramatic oils, there are as many ways of creating color, design, and atmosphere through flowers and foliage as there are people who want to paint. The following chapters will give you an insight into what to look for and how to achieve your aims.

BEFORE YOU START

Turning your ideas into reality depends on practicalities. Organize your space, the tools, and the media you need, so that you can focus on the inspiration.

The workplace

If you are lucky enough to have a studio, you will probably have organized your working space, but if you have to work on the kitchen or dining-room table some planning will help make you achieve good results.

Light is the most vital consideration. Daylight from a north-facing window is the best source, as this avoids having sunlight shining on your work, which can make the dramatic extremes of light and shade very difficult to record—it will also cause the flowers to wilt quickly. If you cannot achieve north light, shading should be considered at certain times of the day. If you intend sitting down and doing detailed work you do not want shadows cast over the work, so ideally you should set your table at right angles to the light source, so that it comes from over your left shoulder (reverse this if you are left handed).

Do not rule out artificial light, as it has advantages when used correctly. A table lamp with a cool bulb is a great asset during the short days of winter. Daylight simulation bulbs have now become widely available, and there are also desk- or floor-standing lamps utilizing gas-filled tubes. These, which use a low voltage and thus do not heat up as a filament bulb does, give a clear light, making color matching at night virtually the same as during the day. Most artists find that if they have started the work in daylight and fixed the colors, they can continue to work in artificial light, checking that the colors are correct the following morning.

MAKE YOURSELF COMFORTABLE If you are doing detailed work sitting down, make sure you sit at a comfortable height and are not scrunched up over your work. If you work flat find a way to raise your work a little, so you can be more upright. An adjustable drawing board is ideal, but a sloping board, even a breadboard propped up on a couple of bricks, can help, so long as it is firm. A seat that slopes slightly down at the front helps greatly; repetitive strain injury is a real danger for the detail addict, as are back and neck problems. If you are painting large and working standing at an easel you are less restricted, and can move around and view your work from a distance from time to time. A stool to perch on now and again could be all you need.

Board
A table easel is the ideal option, but any board with a firm base that allows the work to be taped to it will do to get started.

Seating
Use a seat that keeps your weight evenly balanced and your back upright, to avoid strain or injury. Good posture is essential.

Paints/practice sheet
Make sure the work surface has enough space for all your utensils, paints, rough sketches, and practice sheet, and keep it orderly.

Pencils/brushes
If you do not have a purpose-made brush holder, an old mug or jar will keep brushes bristle-up and prevent them from rolling away.

Natural light
If you are right handed, work with daylight coming from over your left shoulder, and vice versa. You should install a blind as a filter.

Jug of water
Have plenty of clean fresh water available, as you will need to dilute the paint with clean water and rinse the brushes out frequently.

THE SUBJECT Set up the flower group or pot plant at a distance that enables you to see the overall proportions, otherwise you will have problems fitting it on the working surface. The composition needs to be sufficiently far away to make it small enough to cope with. If you are depicting tall gladioli or elegant lilies, for example, you want to be able to give them their full splendid height. You need to take control of the space available, so do some preliminary drawings to work this out. When it is time to put in the detail you can bring the flowers closer—or better still, move yourself nearer, so the pattern of light and shade does not change.

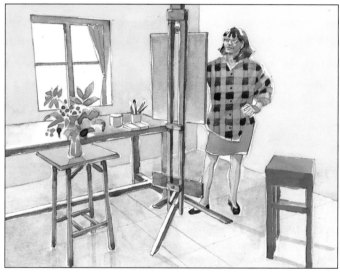

Working at an easel
When painting larger work, you need the perspective of distance and to be able to move around, so have a stool to perch on and a table for extra paraphernalia.

Artificial light sources

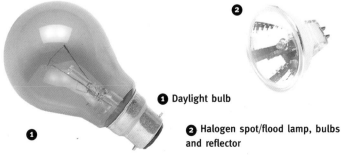

❶ **Daylight bulb**

❷ **Halogen spot/flood lamp, bulbs and reflector**

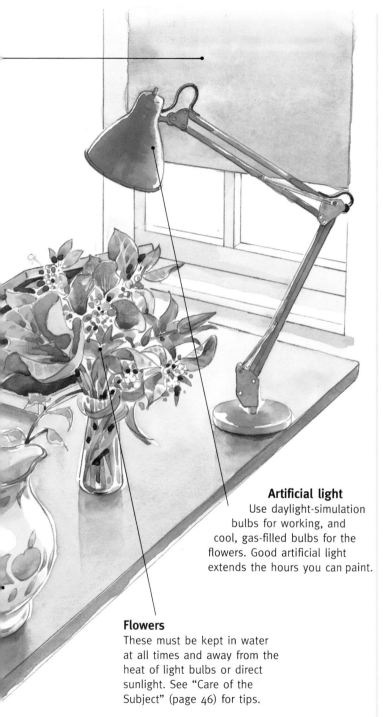

Artificial light
Use daylight-simulation bulbs for working, and cool, gas-filled bulbs for the flowers. Good artificial light extends the hours you can paint.

Flowers
These must be kept in water at all times and away from the heat of light bulbs or direct sunlight. See "Care of the Subject" (page 46) for tips.

Brushes and other tools

Brushes are the extension of the artist's hand, so choose them wisely, and look after them well. The type of brush depends on your chosen medium and method of working.

But brushes are not the only implements for carrying paint from the palette to the working surface. Artists also use painting knives, sponges, and sometimes their fingers. Knives can be used for both mixing and painting. Palette knives are spatula-like and not very flexible, but special painting knives, with wooden handles and a cranked neck, are available in different sizes and shapes. The side of the blade is used to paint straight narrow lines and the tip for thick applications of paint.

Small pieces of natural sponge can be used for dabbing on paint to create textured areas, and for laying irregular washes, but for flower painting in watercolor they are most useful for removing excess paint or dabbing into it to make soft highlights.

CHOOSING BRUSHES Sable brushes are the best for watercolor work, as they are springy and hold a lot of paint. They are expensive, but one really good brush will last longer, and perform the job of two or three sizes in a cheaper version because it holds its shape so much better. However, a large sable wash brush, size 8 or more, may prove too costly, so you might consider a mixed-hair or synthetic one. There are squirrel hair and polyester brushes in the larger sizes.

Bristle brushes, usually hog's hair, are traditionally used for oil painting. These are made in different sizes and three shapes: flat, round, and filbert. Long-handled sable brushes are also made for work in oils, less expensive than the Kolinsky sable watercolor brushes. These are normally reserved for final detail. Some of the synthetic brushes designed for acrylic work can be used also, and are favored by artists who like smooth effects, but beware of the cheaper synthetic brushes, which could be harmed by contact with turpentine.

Bristle brushes can also be used for acrylic, but there are several ranges of synthetic brushes made specially for the medium. These are preferable because the paint dries fast and can clog very quickly unless washed out repeatedly. Any brushes need

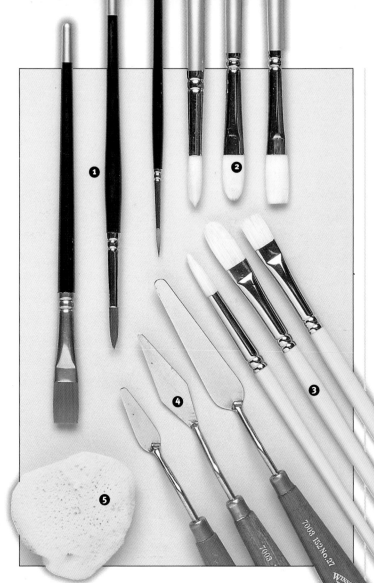

Brushes
Brushes and painting knives of varying shapes all help you describe what you see as well as building a lively paint surface.

1 Watercolor brushes, made in sable and various synthetic mixes, and in two main shapes (flat and round), and a wide range of sizes.
2 Long-handled synthetic brushes, especially made for acrylics, but can also be used for oils.

3 Bristle brushes, the traditional oil-painting brush, made in three basic shapes shown here. From left to right: flat, filbert, and round.
4 Three painting knives. Unlike palette knives, mainly used for cleaning up, these are highly flexible, and have cranked handles.
5 Sponge for dabbing on or taking off watercolors.

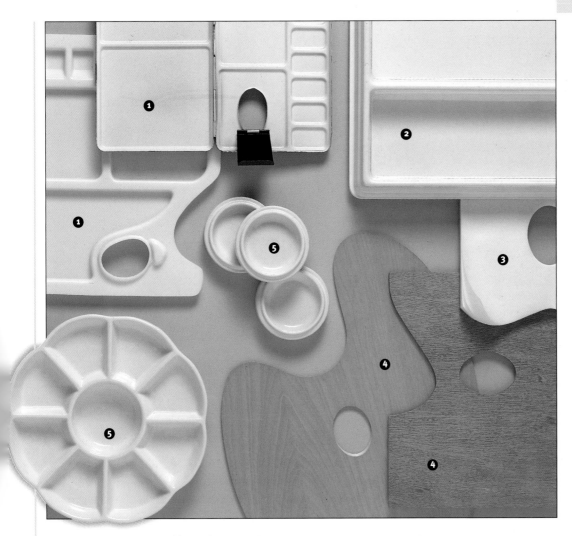

Hints and Tips for Care of Brushes

A carefully cleaned brush lasts longer.

• Keep brushes scrupulously clean to extend their life.
• Never leave a brush standing on its head or it will go out of shape.
• Always clean out your brush at the end of a painting session.
• Make sure you rinse out the color in the hairs/bristles in the ferrule.
• Sable—roll gently between finger and thumb using soap then rub gently on the palm of your hand—right to the ferrule—and rinse well.
• Shape the hair/bristle back into place before leaving to dry.
• Do not put brushes in your mouth—some pigments are toxic.

to be kept wet while you are painting, but avoid leaving them point down in a water jar for too long. Some artists use a painting tray which slopes, giving a shallow reservoir of water at the bottom in which the brushes are placed, or a purpose-made water pot with a handle shaped like a spring which holds the brushes, allowing them to be suspended in the water.

PALETTES Palettes for mixing paints come in all shapes and sizes. For oil paints the traditional wooden palettes with a hole for your thumb are still popular, but do not use these for acrylic. For this you need a non-porous surface, or the paint will adhere permanently. For watercolors the box lid is sufficient for some, but most prefer more space, and use white china or plastic palettes as well.

Palettes

Boxes of watercolor paints often make provision for mixing, but a separate palette can be essential, especially for larger works.

❶ Plastic and metal palettes with compartments and a thumbhole.
❷ "Stay-wet" palette for acrylics.
❸ Paper tear-off palette.
❹ Oil painter's wooden palettes.
❺ Round, deeper welled receptacles for watercolors.

Paper

For watercolors and pastels, paper is the obvious choice of surface. The texture will affect the appearance of your work, so consider what you are trying to achieve.

Machine-made watercolor paper is made in three textures: Rough, Smooth (also called hot-pressed), and Not (short for "not hot-pressed," and sometimes known as cold-pressed). Reputable makes of watercolor paper should be acid-free.

TEXTURE AND WEIGHT The heavier the texture, the more the brushstrokes are broken up, so Rough paper is less suitable for detailed work than the other two. The most popular choice is Not, which has a little texture, but still allows for fine work. Hot-pressed paper has a less absorbent surface that can cause wet washes to form pools, but it can be a good choice for detailed work with fairly dry paint. You can buy watercolor paper either as whole large sheets or in pad form. Until you have discovered what you like, experiment with small sample pads.

The paper also comes in different weights, which are expressed as pounds per ream. Sketching pads usually contain paper of between 90 and 140 lbs, but sheets go up to 300 lbs in weight. Any paper lighter than 140 lbs needs to be stretched before use (see pages 16–17) unless you are working on a very small scale and using the paint quite dry, or the water will cause it to buckle. If you work very wet, you may need to stretch even 140 lb paper.

PASTEL PAPERS Oil pastels can be used on more or less any paper, but papers for chalk pastel need to have a slight texture, or "tooth," to hold the powdery pigment in place. Various inexpensive surfaces can be used for experimentation, including brown wrapping paper (the non-shiny side) and wallpaper lining.

There are two types of paper made especially for pastel work, one with an even overall texture resembling fine chicken-wire (you can also use the "wrong," less heavily textured side), and the other with a stripe texture. These are available in a range of different colors. Pastels are usually done on colored paper, because it is difficult to cover the paper fully unless you work very heavily, and specks of white can show through the pastel. The more brightly colored sheets can be limiting as a background; choose a neutral, medium-toned color such as beige or warm gray.

Stretching paper

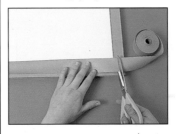

1 You need a board that will not warp, such as thick plywood, brown gummed paper, and a sponge. Lay dry paper on board and measure lengths of gumstrip.

2 Thick paper must be soaked in a bath tub or tray. Thinner paper can be wetted as shown. Wet wrong side first, then turn paper over and repeat for right side.

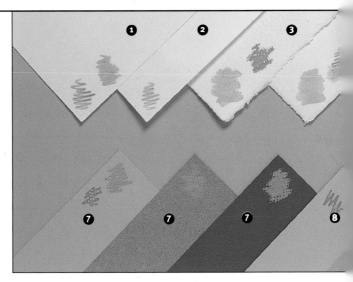

Using pastel papers

Neutral-colored pastel papers are the best to start with. Pastel papers can also be used for paint—watercolor, gouache, and acrylic—but should be stretched first or it may buckle.

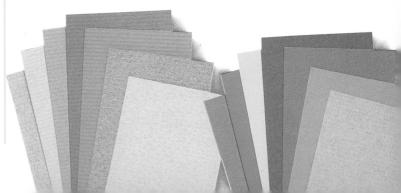

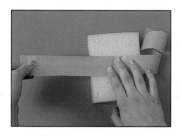 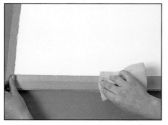

3 | Wet the sponge again and take one of the pieces of gumstrip over it to dampen it. Make sure it is dampened evenly; avoid making it too wet.

4 | Stick down first piece, then damp other three. Gumstrip should overlap paper edge by about ½ inch or it may tear away. Go over it lightly with sponge as you lay it down.

Types of paper
Papers come in varying thickness, textures, and colors. Some are more absorbent than others, and each has special qualities; experiment to find the best for your needs.

❶ Drawing paper used for dry drawing media, such as pencil and colored pencil.
❷ Parchment paper, sometimes used for watercolor pencil.

Vellum and Parchment

Manufactured vellum

Real vellum

Vellum and parchment should be mentioned in a book on flower painting. These are more for the truly botanical artist and the detail addict. Vellum is the finest grade of calf or goat skin, while parchment is thicker and comes from goat or sheep.

Vellum is absorbent, provides for crisp detail, and can be used for either watercolor or thinned oil paints. Paint fairly dry—it will not accept a wash. Mistakes can be gently scratched out with a craft knife and highlights can be produced the same way. There is a hair side and a flesh side. The flesh side is the smoother but can have blemishes. The surface must be absolutely clean. Pumice powder can be used for this but remove all traces before starting work. A little ox gall, on cotton balls rubbed over the surface, de-greases and provides a slight "tooth" for the paint.

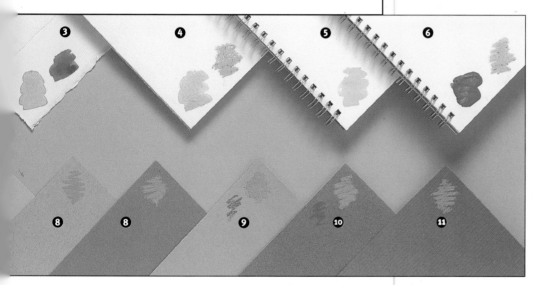

OTHER PASTEL SURFACES Some artists who like to build up pastel color thickly find that the texture of cold-pressed watercolor paper suits them well. The paper can be tinted in advance with watercolor or acrylic. There are also two special papers: artist's sandpaper and pastel board. This is made from tiny particles of cork, which makes it softer and less scratchy than sandpaper.

GOUACHE AND ACRYLIC Any of the watercolor papers can be used for gouache and for acrylic used fairly thinly. You can also use pastel papers for both these media, but the thinner type should be stretched to prevent buckling. For detailed work in acrylic, watercolor board or primed mat board provide a smooth surface. For thick applications and impasto work you will need canvas or a rigid board (see p.16).

❸ The three surfaces of watercolor paper: Rough, cold- and hot-pressed (the smoothest).
❹ Pad of watercolor paper, useful for outdoor sketching.
❺ Spiral-bound watercolor pad.
❻ Spiral-bound acrylic pad.
❼ Mi-Teintes pastel paper, in beige, gray, and dark blue.
❽ Ingres pastel paper, also good for charcoal and soft pencil.
❾ Sheet sandpaper for pastel.
❿ Pastel board.
⓫ Brown wrapping paper, an inexpensive surface for pastel.

Canvas and board

Thick, buttery oil paints need a firm base. The traditional surface is canvas, stretched over a wooden framework so that it is taut but slightly springy.

Unless the canvas is sealed, or primed, the oil from the paint sinks in so that the colors become matt and dull, and many more layers are needed to build up a glow. For acrylic work, priming is not strictly necessary, because there is no oil to rot the fabric, but it can provide a pleasanter surface than raw canvas, and keeps the colors brighter.

PREPARING CANVAS Canvases can be bought ready stretched and primed, but you can save money by preparing your own, as shown right, and you can choose the size you want. Canvas—linen, cotton, or burlap—is made in various different weights and textures and sold by the yard by specialist suppliers and some of the larger art stores. You can also paint on cheesecloth, but this needs to be stuck down on board as it is too flimsy to stretch. To start, it is worth trying out small quantities of several different types of canvas, to find out whether you like a smooth, fine-grained surface or a heavily textured one such as burlap.

Each primer gives a different "feel." For example, acrylic gesso primer, a good all-round one for both oil and acrylic painting, is more absorbent than most oil primers. To retain the natural color of the canvas, you can prime it with glue size or even varnish (for oil painting) and acrylic matte medium (for acrylic). Do not use oil primer for acrylic; it is greasy, and will repel the water-based paint.

BOARD Primed painting boards provide a cheaper option than canvas. These come in varying textures, and are ready primed, usually with an acrylic primer that makes them suitable for both oil and acrylic. The cheaper ones have a simulated canvas pattern stamped on the surface, but the better-quality ones have genuine fabric bonded to a support.

Oil painters of the past often painted on wood—pieces joined together to form large panels. Wood is still sometimes used, but masonite is a less expensive alternative, ideal for those who like a smooth, non-textured surface. It can be given a slight "tooth" by sanding down lightly before priming. Paper can also be used for oil painting—Degas sometimes painted on paper—but if it is to last it should be stuck down onto a rigid surface.

Stretching canvas

1 | Lay the frame on the canvas and mark off the amount you need, allowing a 2½ inch overlap on each side. Cut the fabric with sharp scissors.

2 | Fold the canvas over the stretcher and staple or tack it in the center of first one of the long sides and then the other, pulling the canvas as taut as possible.

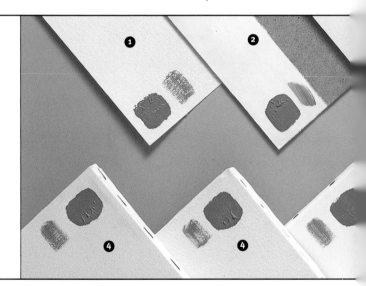

Home-made canvas board

 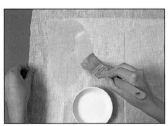

1 | Cheesecloth is too flimsy to stretch, so must be stuck on masonite. Make this from any cotton fabric. Place board on fabric, cut around it, allow an overlap.

2 | Stick cheesecloth down with acrylic gloss medium. For a thicker fabric, stick the back and turn it over. But the open weave of cheesecloth lets it soak through.

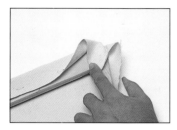

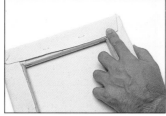

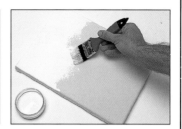

3 Continue in the same way, working outward to each corner, and then fold in the corner flap neatly. The corner must not be too bulky or the canvas will not fit into a frame.

4 Finish the corner by folding it over along the stretcher joint and then staple or tack. Take care not to staple into the joint itself.

5 Prime the canvas with acrylic gesso, using a household brush. If you prefer to keep the natural colour, prime with acrylic matte instead.

Preparing surfaces

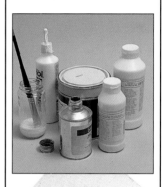

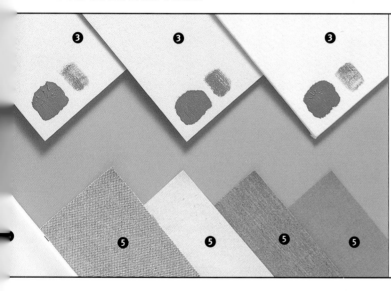

Types of canvas and board

Surfaces for oils and acrylics can be bought ready to use, or use masonite and prime it yourself.

❶ Primed paper for sketching.
❷ Masonite can be used smooth side or rough.
❸ Canvas boards are suitable for both oils and acrylics.
❹ Pre-stretched canvas is available in rough, medium, and fine textured surfaces.
❺ Canvas made from linen or cotton can be purchased by the yard for stretching and priming.

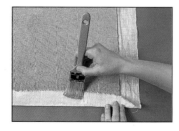

3 When you have completed gluing, turn the board over, fold in the excess fabric on each edge, and glue well.

4 After folding and gluing, reinforce the edges with masking tape. This is not strictly necessary for cheesecloth, but helps with thicker fabric.

5 Cheesecloth is so flimsy, it is impossible to keep the grain straight. If you paint thinly, and like the grain of the canvas to show, try a heavier fabric. Prime with gesso.

❶ Acrylic gesso primer, easy to use. **❷** Picture varnish, oils only. **❸** Glue size, for burlap or other porous surfaces. **❹** White oil-based wood primer, not suitable for acrylics. **❺** Matte acrylic medium suitable for oils or acrylics.

Watercolor

Flowers can be painted in any medium, but the delicacy and translucency of watercolor makes it an ideal match for the subject.

The paint can be bought either as tubes or pans (half- or whole-pans) and is made in different qualities—"artist's" and "student's." It is best to buy the more expensive artist's quality; for flower colors in particular you do not want to struggle with muddy or grainy pigments, and the best paints are less prone to fading, a problem which besets watercolors. Colors are constantly being improved and up-graded, but unfortunately it is often the "flower" colors that fade the fastest.

AUXILIARIES AND MIXERS Watercolors are diluted with water, which must be kept clean, so have two or three pots on the go to avoid muddying the colors. If you live in an area where you are worried about what comes out of the faucet, use distilled water, bought from a drugstore. There has been discussion about what chemicals react with certain pigments but no proof that it changes anything.

Masking fluid is a useful extra. It is used to put a waterproof layer on any parts of the work that you want to keep color away from. It is painted over, then peeled off to leave white paper.

Flow improvers such as ox gall added to the water makes the paint run more freely—though it is advisable not to use too much. Another use of ox gall is to de-grease the paper and make the surface accept the paint more smoothly. Gum arabic is sometimes used to add extra body to watercolor so that it flows easily from the brush, yet each brushstroke remains distinct. Again, do not use too much, or the paint may crack. Aquarella or watercolor medium serve the same purpose.

Size (a form of weak glue) can be used to lessen the absorbency of card, board, or paper by making it more waterproof.

GOUACHE Gouache is an opaque version of watercolor, sometimes used hand-in-hand with it. It was originally a designer's medium, and not built to last, but nowadays, if bought from a reputable manufacturer, gouache colors are of good quality, and the color range is wide. They dry fast and with a matte finish.

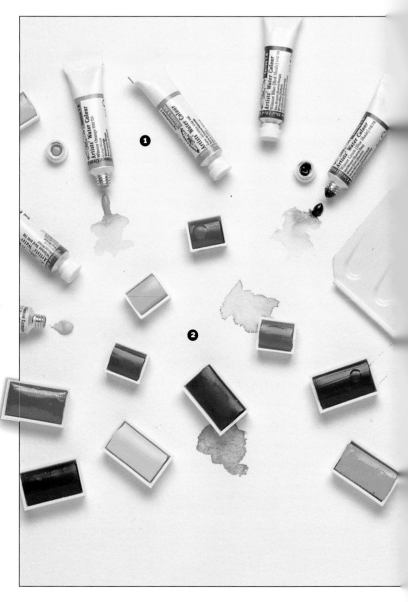

Types of paint

Water-based paints come in tubes and pans of color. If you use only small amounts of paint at a time, pans are probably the most suitable. Paint in tubes stays clean more easily, and so long as the top is replaced, lasts for a long time. Gouache (opaque watercolor) is available in both tubes and pots.

❶ Tubes of transparent watercolors.
❷ Pans and half pans.
❸ Boxed set of half pans.
❹ Tubes of gouache.

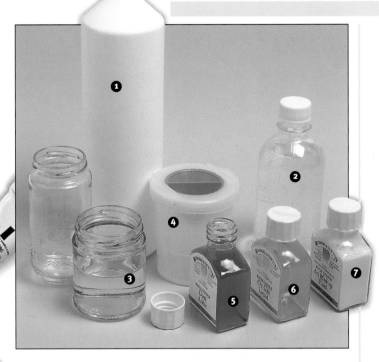

Water containers and media for watercolor paints

1 A plastic bottle is ideal for carrying water for outdoor work.

2 Distilled water.

3 Jamjars are adequate for indoor work.

4 A plastic container with a non-spill lid.

5 Gum arabic gives the paint extra body.

6 Ox gall cleans grease from surfaces and improves "acceptance" of paint if a couple of drops are used in the water.

7 Masking fluid reserves highlights.

Intensity of color

Watercolor dries much lighter than it appears when wet, so test your colors on a spare piece of paper.

Pastel

The huge color range of pastels make them a tempting choice for flower painters. This fascinating medium gives a soft look to flowers without losing their brightness and depth of color.

Pastels were first used in the 17th century, and have a much better lasting quality than their fragile appearance would suggest. Old unfixed pastels have come in for restoration with the glass totally obscuring the picture where the pastel dust has come free, but after cleaning the glass, have been found to be as bright as the day they were done.

There are two main types of pastel—chalk pastels and oil pastels, the latter a relatively recent development. The former are made by mixing pigment with water and binder, while oil pastels are bound with wax and oils. Chalk pastels range from hard to soft; the softer the pastel the less binding has been used. The category also includes pastel pencils, which are excellent for fine work. Oil pastels can be used with oil paints, in fact they can even be thinned with turpentine or mineral spirits and used almost as a painting medium. Chalk pastels mix well with acrylics, but are a beautiful medium in their own right, capable of a rich variety of effects. Hard and soft pastels can be mixed, with the former sometimes used for the early stages of a work, subsequently overlaid with soft pastel. Do not use an eraser as it can build up a shiny, slippery layer of color that you cannot work over. To blend colors, use a tissue or torchon (a stump of soft paper) or even a cotton swab. Some artists use brushes to blend or add textures to their work.

AUXILIARIES Fixative is probably the only extra you need for chalk pastels. There are always arguments between artists as to its use—some claim never to use it because it sacrifices the freshness of the work, and indeed does tend to affect the colors slightly. Other artists use it between layers to enable them to build up the colors thickly.

Blending pastels

For very small areas, a rolled-paper stump called a torchon can be used. Notice, however, that this makes quite a lot of dust on the surface, while the finger does not.

Your finger is the best "tool" for rubbing one color into another to create soft gradations. Cotton balls or a soft rag can remove the color from the surface.

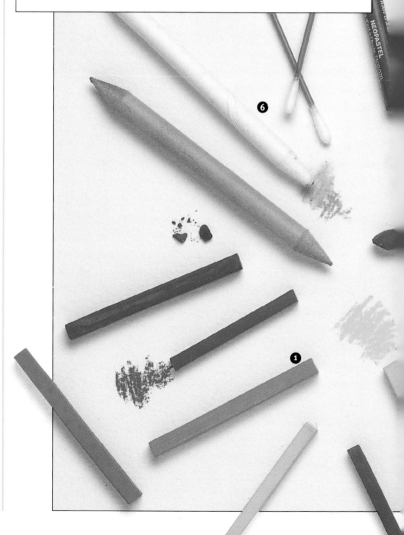

Using fixative

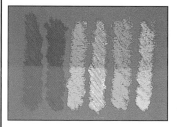
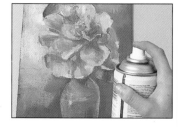

Fixative darkens work slightly, especially if you are working with light colors on dark-colored paper. It is useful to make a test card like this to check the effects.

Hold can about 6 inches from paper and spray from side to side, avoiding concentration in one area.

Cleaning pastels

However carefully you store pastels, you can't always keep them clean when working. Put dirty pastels into a container of ground rice and shake them. Then empty the container into a strainer or a colander to strain off the rice.

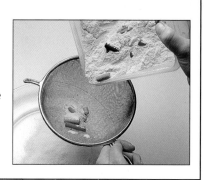

Types of pastel

Pastels are made in various types, but the main difference is between chalk and oil pastels.

❶ Hard (chalk) pastels are square-sectioned and have a greater proportion of binder than the round ones. They are used for more linear work.
❷ Oil pastels are bound with oils and waxes, and are not compatible with soft (chalk) pastels.
❸ Large soft pastels for broad effects.
❹ Soft pastels are less controllable than hard pastels, being powdery and liable to break in mid-stroke.
❺ Pastel pencils give good control.
❻ Torchon and cotton swabs for blending colors.

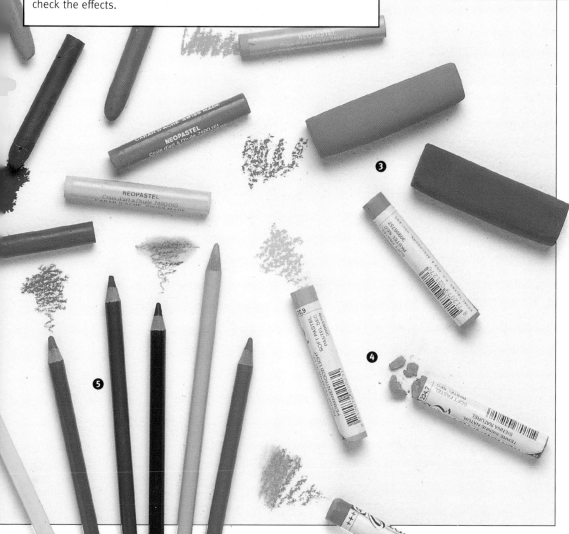

Acrylics

Acrylic is one of the most versatile and convenient of all the painting media, mixing well with other media such as pastel. It can be applied thickly to resemble oil paint, or thinned with water to provide transparent washes.

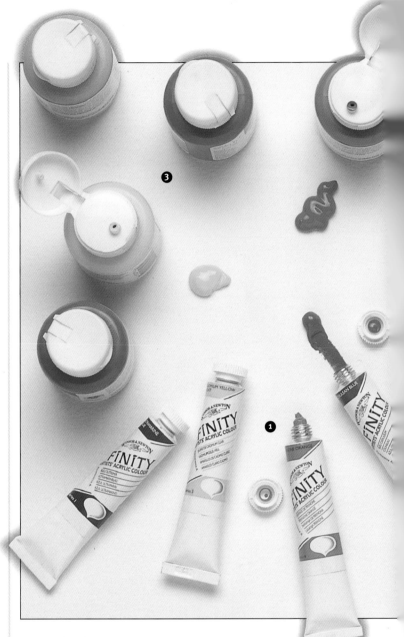

Acrylics are water-soluble, which means that you can wash your brushes in water, and have none of the odor associated with oil paints—a bonus for those who find the smell of turpentine unpleasant. Another advantage is that you can work on more or less any surface provided it is not greasy.

Acrylics differ from other paints in that the pigments are bound with a synthetic resin. Once dry, they form a "plastic" skin which cannot be removed. Paintings in acrylic are thus tough and durable, less prone to accidental damage than pastels or watercolors. The paint dries fast, which can be an advantage when working with flowers, but this does prevent you from moving color around on the surface, as you can with oils.

Acrylics are sold in both tube and pot form, and there is now a liquid version on the market which handles like an ink. You can fill a technical pen or airbrush with it to provide brilliant, transparent color that is ideal for a touch of instant sunshine in any flower piece.

MEDIUMS Acrylic can be asked to do many different jobs, and there is a large range of mediums that make it behave differently. Mixed with water—the principal medium—it dries slightly matte. Gloss medium makes the paint more transparent and adds a luster, while matt medium gives a less obvious sheen. Both these are used for glazing (transparent overlays of color). There are various mediums for thickening the paint for knife-painting and impasto methods, and others for adding texture. There is also a retarding medium which slows down the drying time, though it will still dry faster than oil paint used at the same consistency. However, retarder is only used for thick applications, as water affects its performance.

Varnishes are available in both matte or gloss versions. These can be used to protect work which is to hang unglazed.

Types of paint

Acrylics can be used so that they resemble both oil paints and watercolors, but remember that once dry they cannot be moved, making wet-into-wet and lifting out techniques more difficult. Acrylics can be combined with other media, for example as an underpainting for oils, or more commonly pastels, but you cannot use them over an oil-based medium.

❶ Tubes, made in sizes from 0.67 fl.oz. to 4 fl.oz.
❷ For opaque work, you need the large-size tube of titanium white.

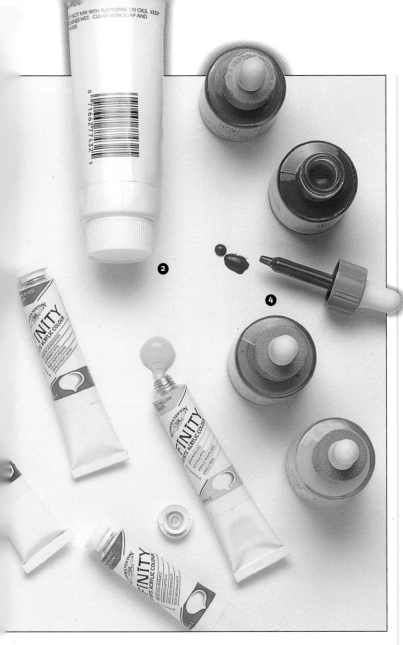

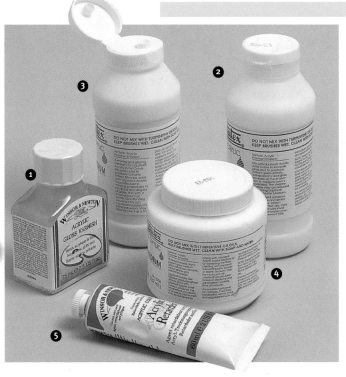

Acrylic mediums

To expand the versatility of acrylics, mediums can be added.

① Acrylic varnish in matte and gloss is mainly a protective varnish, but can be used as a medium.

② Matte medium, for making the paint thinner and more transparent. Used for glazing.

③ Gloss medium has the same uses, but gives a thinner finish.

④ Gel medium thickens the paint for impasto work.

⑤ Retarder slows down the drying time of paint.

③ Pots of acrylic paint have a slightly runny consistency.

④ Liquid acrylic in a range of brilliant colors, for airbrushing, drawing, or applying glazes.

Texture mediums

Mediums you can mix with paint to provide texture.

① Paint mixed with a texture gel medium called "glass beads."

② Paint with no added medium, used straight from the tube.

③ Paint mixed with a texture gel medium called "blended fibers."

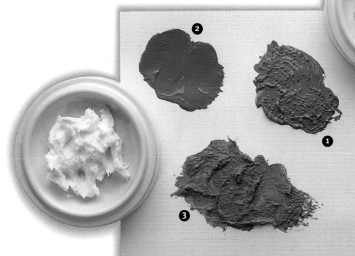

Pencil and colored pencil

There is a vast range of drawing materials on the market nowadays, from the humble graphite pencil to the versatile water-soluble colored pencil.

The word pencil originally meant an artist's brush, because the hairs were encased in a wooden holder. This is why we now have so many different drawing implements that come under the heading of "pencils." The standard pencil is made of graphite, which is slightly greasy, while charcoal is not. The latter are thus better for using under pastels, which do not lie well over graphite —just rubbing out can leave a greasy surface on the paper.

Graphite pencils range in hardness from 6H to the softest, 6B. The hardest produce very pale fine lines, but can seem to scratch the surface of the paper. This is especially true if you are outlining on vellum or for pastel work; a very light touch is needed if you do not want to be left with an indelible line. Some manufacturers produce chisel-shaped soft pencils for more variety of line and coverage. Graphite sticks can also be obtained in the form of a thick stick, without the wooden casing.

Charcoal pencils are also graded for hardness and the softer ones are useful for drawing an outline on canvas. You can use charcoal in stick form, but the pencils keep your fingers cleaner—unless you start smudging it out.

Colored pencils and crayons come in many ranges and makes. They make beautifully soft delicate finished pictures as well as being very portable for sketching and color roughs. Watercolor pencils are, as the name suggests, water-soluble. They can be used dry, in the same way as ordinary colored pencils, or the color can be spread with a brush dipped in water. It needs some practice to achieve the best results, but these pencils can give the best of both worlds—drawing and painting.

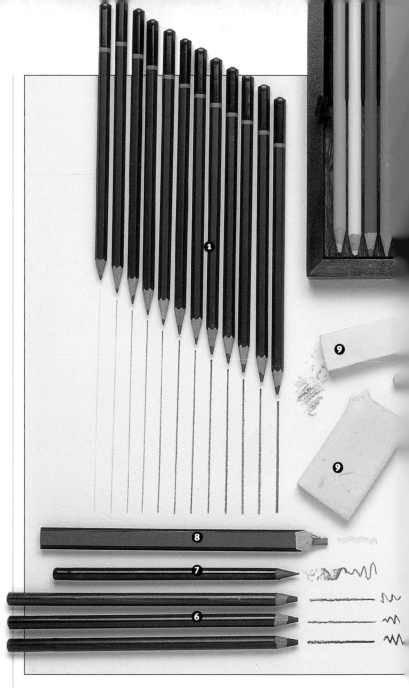

Graphite and colored pencils

The range of different pencils and their uses is a subject in itself. Graphite pencils can be used just to outline the flowers and to establish their placing on the paper, or they can become part of the painting. Colored pencils are equally suited to both sketching and finished works.

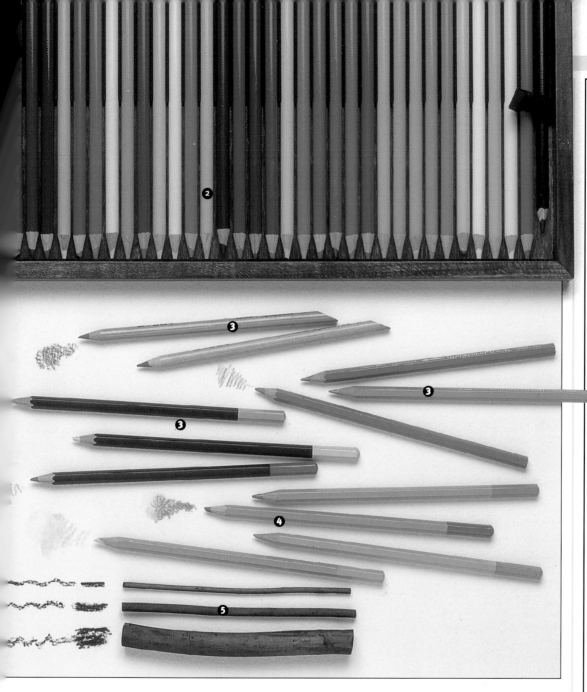

Using watercolor pencils

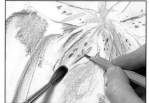

1 Draw the flower using graphite and water-soluble colored pencils, then soften in the areas of color with a damp brush.

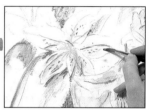

2 Extend the colored pencil out on the petals to produce a pale wash of color. Use dry colored-pencil lines on the stamens.

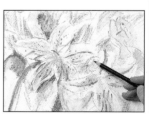

3 Repeat the process, using combinations of the techniques, emphasizing the brightest colors with pencil work over damp areas.

❶ Graphite pencils in a range from hard to soft.
❷ Boxed set of dry colored pencils.
❸ Selection of soft to hard and waxy colored pencils.

❹ Water-soluble pencils, which combine well with watercolor.
❺ Sticks of charcoal, thick, medium, and thin.
❻ Charcoal pencils of differing grades.

❼ Graphite stick (usually graded as for pencils).
❽ Flat, spatula-like pencil for thick and thin lines.
❾ Erasers, putty (below), and plastic (above).

Oil paints

Oil paint is an exciting medium to use, allowing you to exploit the marks of the brush to build up the forms and shapes of flowers.

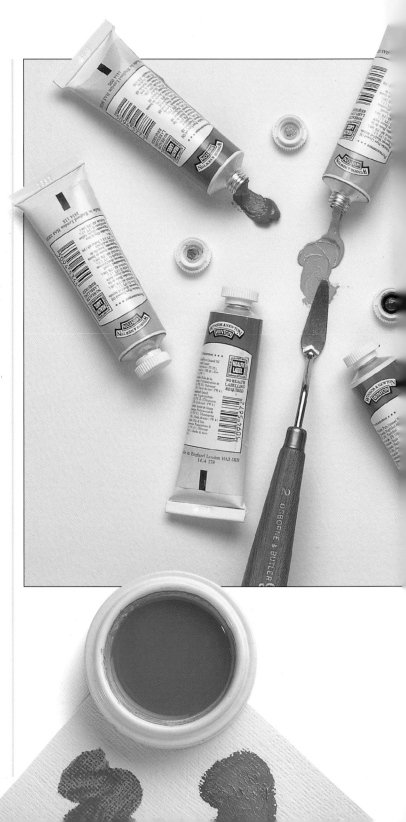

Those who are accustomed to painting in oils will probably be less interested in detail than in capturing the essence of the flowers—their overall colors and shapes, and the masses of light and shade. But although oil paint is primarily thought of as a medium for broad, impressionistic approaches, it is capable of fine detail too. Think of the Dutch flower paintings of the 17th and 18th centuries, in which every petal, leaf, and stem was treated in exquisite detail. If you want to work in this way, choose a fairly smooth surface that does not break up the marks of the brush, and thin the paint with a greater proportion of turpentine to linseed oil, or use a thinner type of oil medium.

Oil paint is not normally prone to fading, but it is still wise to buy the best-quality paint you can. Like watercolors, oils come in both "artist's" and "student's" quality, and the pigments are more reliable in the former. As long as you keep the tops of the tubes well screwed on they will last for years.

MEDIUMS Oil paint can be used undiluted, straight from the tube, but are often thinned slightly, traditionally with linseed oil and pure distilled turpentine. A half and half mixture is most usual, with more turpentine, or turpentine alone, sometimes used in the early stages. Linseed oil comes in different versions—cold pressed, refined, sunbleached, and other processed types—and they vary slightly in thickness, drying time, and color. Some are almost clear and others rather thick and yellow.

Other oils, such as sunflower oil, poppy oil, or even lavender oil can be used. There are also special oil painting mediums produced by paint manufacturers, which dry faster than the traditional oils and can be suitable for more detailed work. Various thickening mediums can be bought for impasto work, and mediums for glazing thin the paint without making it runny.

Varnishes range from wax (which can be buffed to a shine), to varnishes that can be mixed with paint as a medium for glazing. Check the labels to see if they dry matte or gloss.

Mineral spirits or turpentine substitute is used for cleaning brushes and palettes—you can use pure turpentine, but it is very much more expensive.

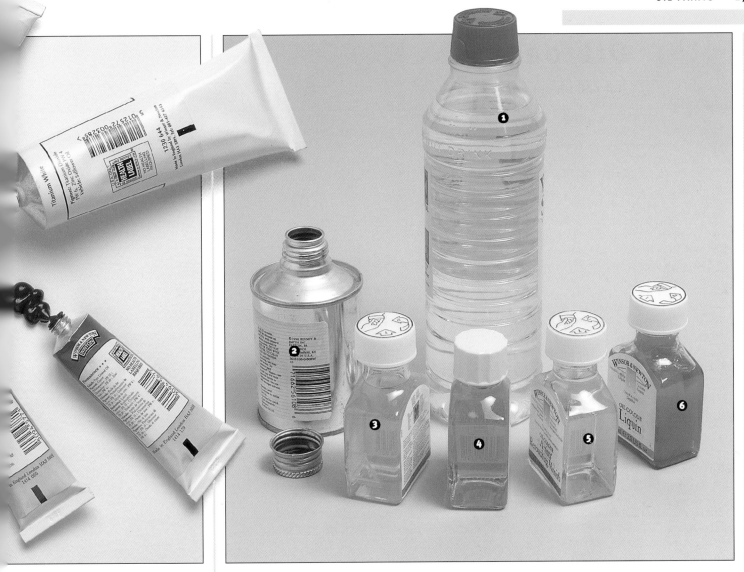

◀ Thinning oil paint

Although oil paint is opaque straight from the tube (*near left*), it becomes transparent when thinned (*far left*). This allows underpainting to show through or layers to be built up, giving depth.

Types of oil paints

Oil paints are sold in tubes, the usual sizes being 0.71 fl.oz. and 1.25 fl.oz. with whites available in larger quantities, up to 4 fl.oz. Pigments can vary according to the manufacturer, even when the names on the labels are the same (*above left*), so look at a hand-painted color chart if possible.

▲ Mediums and cleaning fluid

Cleaning fluids are essential for oil paints. Although the paint can be used straight from the tube, it is usually , thinned with a medium, the commonest being a half-and-half mix of pure turpentine and an oil such as linseed.

❶ Bottle of turpentine for cleaning brushes and palettes.
❷ Varnish for protecting work that is not to be covered with glass.
❸ Artists' distilled turpentine.
❹ Linseed oil.
❺ Artists' retouching varnish used for temporary protection or to restore paint that has gone dull.
❻ Liquin, a synthetic alternative to traditional oil and turpentine, also improves paint flow.

Color choices

The brilliant colors of flowers may tempt you to buy a huge range, but it is better to start with the smallest number you can and practice color mixing.

You may in time find you need some special "flower colors," particularly if you work in watercolor, because mixing more than two or three colors can cause a loss of clarity, but these can be purchased as the need arises.

PAINT COLORS Whatever medium you use, you should have two or three different reds, yellows, and blues. These are called the primary colors because they cannot be produced by mixing other colors. Choosing a crimson (slightly blue) red and a more brilliant one such as cadmium red, will help you mix the different pinks and purples. A good orange (cadmium, for example) is useful as it can be difficult to mix. Some artists maintain all greens should be mixed from various combinations of blue and yellow, but most palettes include at least one green.

Colors—basic to all media

Lemon yellow
Cadmium red
Alizarin crimson
French ultramarine
Cerulean
Sap green
Cobalt blue
Yellow ocher
Raw umber
Hooker's green
Burnt umber
Burnt sienna
Vandyke brown
Payne's gray
Davy's gray
Cadmium yellow pale

Transparent watercolors

Since pigments tend to darken and dry matte when absorbed by the paper, avoid any that are muddy or grainy, to maintain clear, bright flower colors. Many mauves are fugitive, though this is improving, so check which you buy.

Lemon yellow Aureolin

Quinacridone gold New gamboge Oxide of chromium Bright red

Permanent magenta Purple alizarin Permanent violet Winsor violet

Oils and acrylics

Acrylics are a relatively new medium so they have more modern names than oils (e.g. dioxine purple). They share the same basic pigments but are bound by a polymer resin as against an oil carrier.

Titanium white Ivory black

Cadmium yellow Chrome yellow

Indian yellow Cadmium orange

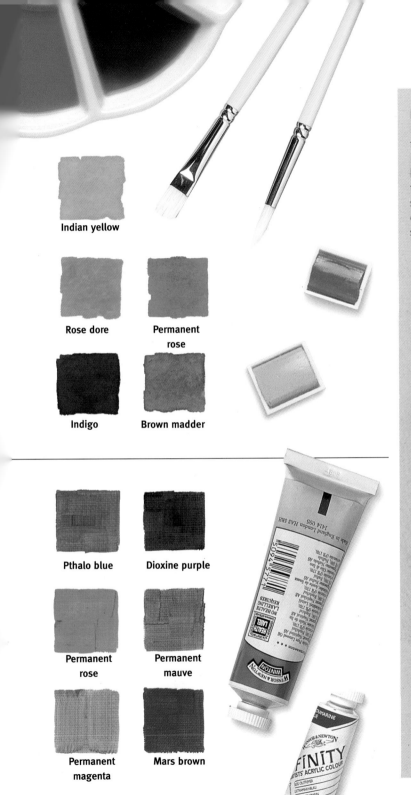

Indian yellow

Rose dore

Permanent rose

Indigo

Brown madder

Pthalo blue

Dioxine purple

Permanent rose

Permanent mauve

Permanent magenta

Mars brown

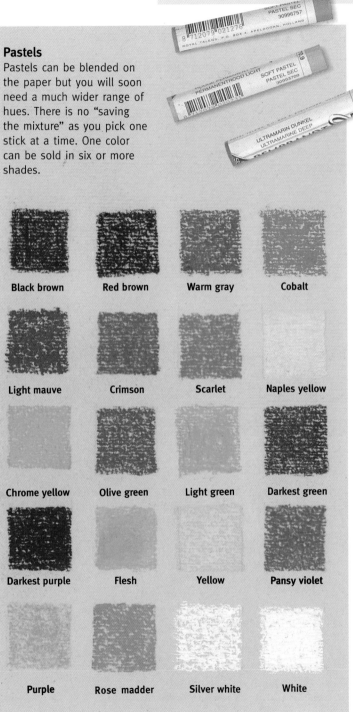

Pastels

Pastels can be blended on the paper but you will soon need a much wider range of hues. There is no "saving the mixture" as you pick one stick at a time. One color can be sold in six or more shades.

Black brown

Red brown

Warm gray

Cobalt

Light mauve

Crimson

Scarlet

Naples yellow

Chrome yellow

Olive green

Light green

Darkest green

Darkest purple

Flesh

Yellow

Pansy violet

Purple

Rose madder

Silver white

White

Mixing colors

Learning to mix colors is a vital skill, which is mainly acquired through experiment. Until you are sure of your ability, try out mixtures before committing yourself.

When working with watercolors always have a piece of paper to try out mixtures, or if there is a margin round the painting, use that; it can be cut or hidden under the mat if framed. The same method can be used for pastels, but in this case they are not pre-mixed in a palette, but overlaid on the working surface.

Opaque paints, such as oils and acrylics, are best tried out on the palette. If the shade appears not quite right when applied, you can correct it by over-painting or, in the case of oils, by simply wiping it off. It is easier to check a mixture than it is with watercolor, because you can load a brush with the thick paint and hold it next to a petal or leaf to check the match.

TWO-COLOR MIXTURES If you want a vivid mixture, avoid using more than two colors, or you may muddy the result. Colors used straight from the tube are always brighter than mixtures; even when only two colors are mixed you slightly reduce the brilliance of both. Mixtures of two primary colors—red, blue, and yellow—produce what are known as secondary colors.

Blue and yellow make green, red and blue make purple, and yellow and red make orange. But there are many variations in the secondary ranges, depending on which reds, blues, and yellows are used, and on the proportions. One blue with different yellows will add sunshine and an orange yellow will produce a browner shade of green. The proportion of red to blue makes a difference to whether you mix a bluey mauve or a warmer maroon. An orangey red mixed with blue will make a color that is more brown than purple. Trial and error will teach you which primary colors to mix to achieve the flower or leaf color you need, and you can then introduce changes in hue and tone to show sunlight or shade. The color can be lightened by adding more water (for watercolor work) or mixing with white—for opaque paints, and darkened with other colors or black. There is a danger you may forget how you achieved a mixture, so make sure you mix enough of it for the job in hand, or make a note of the mixture in case you need to repeat it.

Yellow – Lily

Orange – Gerbera

Red – Rose

Purple - Tulip

Green – Hellebore

Blue - Iris

Primary colors

Red, yellow, and blue; these cannot be mixed from any other colors. In theory, when mixed, they form the basis for every other color. Mix primary red with primary blue and you will have a dull brown/purple. Hence the need for more than three tubes of paint.

Secondary colors

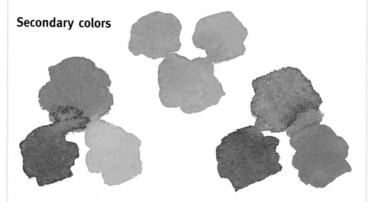

These fall between the primaries, i.e. when two of them mix. Orange = (red+yellow) Green = (yellow+blue) Purple = (blue+red). Two shades of each primary, provide a range of secondary colors.

Cool and warm colors

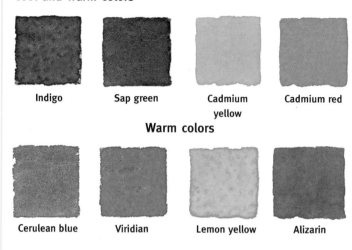

Indigo Sap green Cadmium yellow Cadmium red

Warm colors

Cerulean blue Viridian Lemon yellow Alizarin

Cool colors

Cool colors are those which have a predominantly blue tinge because they reflect cold, blue light. Warm colors have a yellow light to them. Where sun shines on a red flower it could be seen orange/red on one side and purple/red in the shade.

Greens

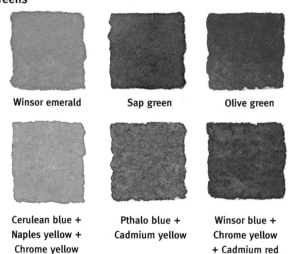

Winsor emerald Sap green Olive green

Cerulean blue + Naples yellow + Chrome yellow Pthalo blue + Cadmium yellow Winsor blue + Chrome yellow + Cadmium red

Leaves are never a uniform green, not even when growing on the same type of plant. Three very different ones, straight from the tube, were mixed with blues, yellows, and reds to illustrate the shades and wide ranging variants.

Interaction of Colors

Green intensifies and projects red forward.

Here the red intensifies the blue and seems to recede.

Placed next to a cool pink it darkens and bleeds into it.

Warm, dark brown makes the red lighter, almost orange.

The chance to paint pure, bright color, is one of the best reasons for painting flowers. Some people maintain that in nature, no colors clash, and you can certainly combine reds and purples, pinks and yellows, and oranges and blues, as long as you understand how one color interacts with another. Colors become more or less vivid by contrast. If you look closely at Monet's painting of poppies in a field you will see that the poppies are actually quite a brownish red; it is the surrounding green that makes them leap out at you. Green and red are complementary colors, so this is an obvious choice, but other backgrounds can accentuate flower colors in exciting ways.

Lightening colors

Two ways keep the color pure. First, using a clear diluent; keeping the pigment thin and letting the white background "pale" it out. The second is to add white which is opaque and blanks out.

Thinning transparent pigments (letting the underneath show through).

Making color paler by adding white (blanking out whatever is underneath).

Darkening colors

The best way to show shadows on flowers is to add increasing strengths of the complementary color. Black may be added, and there are warm and cool blacks, but they all have a deadening effect on clear flower colors.

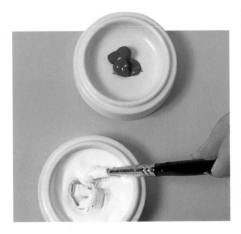

Results of adding black in increasing strengths to yellow (top) and crimson (below).

Mixing browns

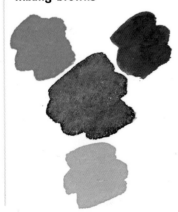

Lightly adjusting a mixture of the three primary colors gives you many neutral or tertiary shades. You will find sympathetic browns for stems, or deep shadows, often arrive without much adjustment if you mix them from the colors already in use.

Red, yellow, and blue mixed together will make brown

Mixing blacks

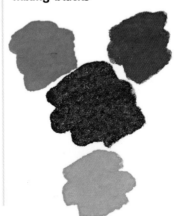

This is an extension of the same process but derived from full strength mixing of deeper shades. Using a greater percentage of any one color will adjust to a cool black (thinned = gray) or warm black (thinned = brown).

A strong mix of red and blue with a small amount of yellow will make black

Color notes

A good way to learn color mixing is to use a system of little squares, which can also serve as notes for future reference. Start with the color nearest to the one you are trying to mix, used in its pure state, straight from the tube, then begin to add another color that you think will achieve the end result and place that mix in a square next to the first. This shows your results from experimenting. You can work in any direction from the first square if you place it in the middle and add other colors to lines coming from the center.

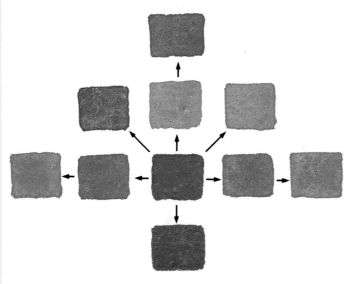

Color notes—recording additions.

Painting shadows

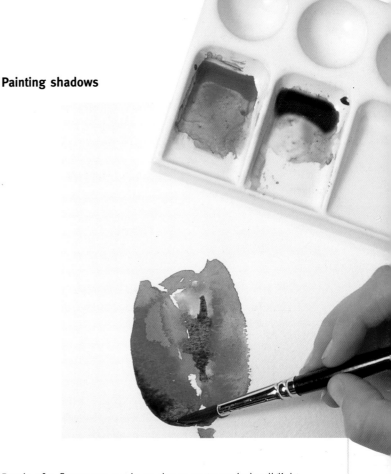

Petals of a flower are rarely so dense as to exclude all light. When painting in the shaded side remember a certain glow comes through in sunlight. The use of cool versus warm is important. Achieve shadows by adding complementary color.

Mixing in gray

A gray can be used more effectively than black or white to tone down greens as it becomes more muted. The variations can be quite subtle on leaves, indicating the contours, lines of veins and even texture and hairiness.

Sap green

Mid-tone gray

Light and shade

The brilliant colors of flowers may be what makes you want to paint them, but to give credibility to your work, you must also consider tonal values.

Tones means the lightness or darkness of a color, and you will see many variations even in one flower or plant. Parts may be catching the light, so that they are light in tone, and others in shadow, and hence dark. Even a white or pale-colored flower may be surprisingly dark in places, for example beneath the petals, and sometimes there may be light shining through a leaf or petal to create a tone so light that it seems to belie the overall color. You will learn how to pick up on this with good observation. When you first sit down to study the subject look for the lightest (almost white) areas and then the darkest shadows (almost black). Everything else will come somewhere in between on the "gray" scale. Make tonal sketches marking important areas so that you get the feel of the distribution of tones.

The fall of light will also create shadows, thrown by an object onto an adjacent surface, or by one flower or leaf onto another. These not only give form to the main subject but "recognize" the surrounding objects, thus linking all the elements in the picture.

Light and shade could be said to be the most important part of a painting, because it is these that give form and solidity to the subject. It is not always easy to judge tones independently of color, but try, as you introduce color, to keep an image of what the subject would look like in black and white. It is helpful to half-close your eyes—try this looking at a painting on the wall. The slightly out-of-focus effect accentuates the pattern of light and dark and reduces the impact of the colors.

Understanding tones

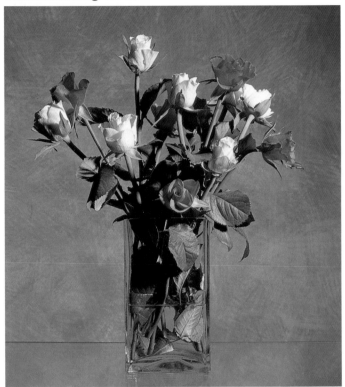

A vase of roses in full color is brightly lit from the side; note the tones, then imagine it in black and white.

As light moves, the tonal qualities shift

Bright side lighting gives contrasts and deep tonal shading to the upright lines.

Soft light from the side gives more overall tonal quality. Each flower has equal emphasis.

Gray scale

Pencil sketches rely solely on varying shades of grays to give shape and form. This gray scale is useful when considering tones in a color painting.

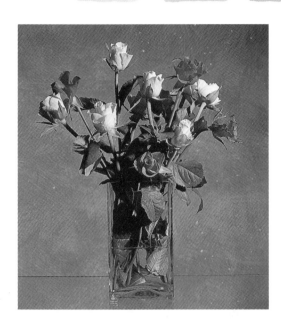

Compare these shapes with the example (*left*). The tips of the red roses are white, and the cream roses have shadows that are nearly black.

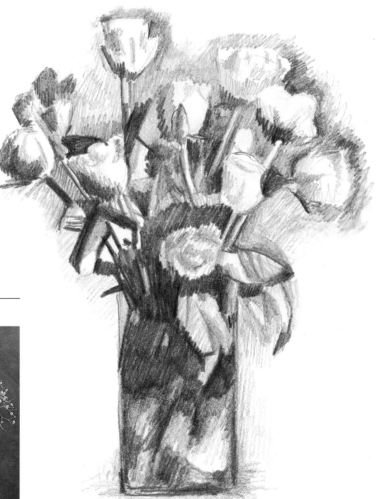

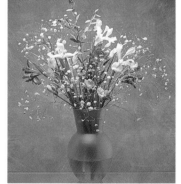

Lit from above, the vase loses emphasis, leaving only subtle tones as guides to shape.

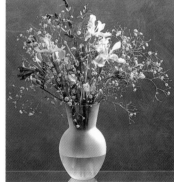

Light from behind reverses the rules as it shines through the translucent petals.

Color may be your first consideration but tones give dimension and texture. Make a monochrome drawing to fix in your mind the light source and consequential shadows.

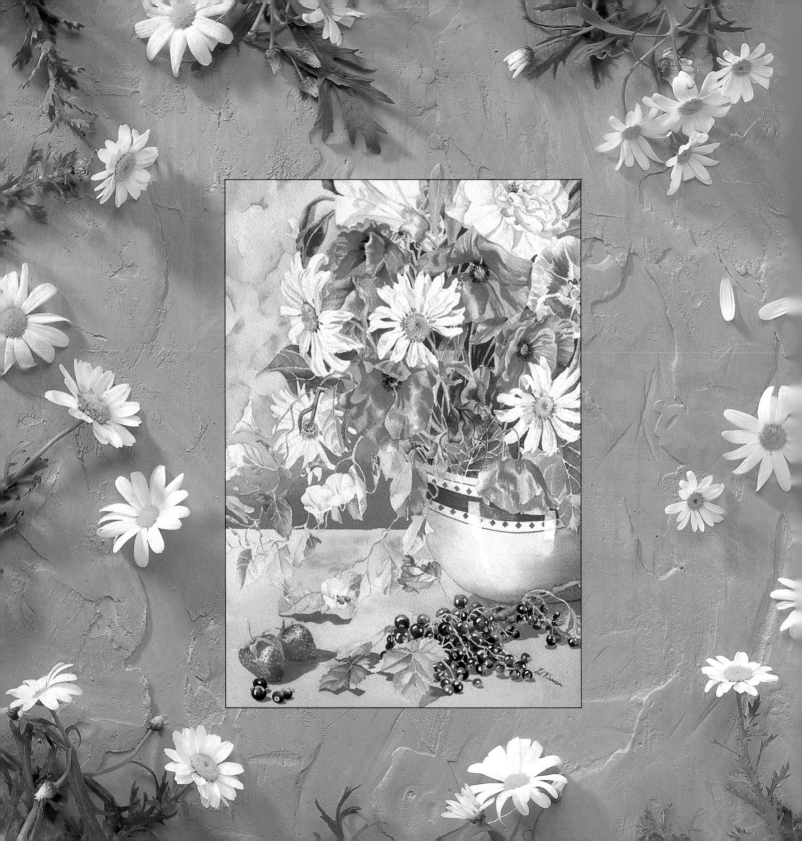

THE FLOWERS

You need time to study the subject, so the flowers must stay at their best. Make sketches, analyse the shapes, and ideas will fall into place.

Basic principles

You do not need to be a botanist to paint flowers, but understanding their basic structures will certainly avoid frustration and help you depict them successfully.

You would not draw a figure without considering the muscles and bones that form it and the way the feet and legs support the body's weight. The same applies to a plant. Why does it have stems and leaves, and what supports the petals?

The purpose of the leaves is to photosynthesize and produce carbohydrates which are used by the rest of the plant, while roots gather water and nutrients and send them back up the stem. The stem must be strong enough to support the flower. It is unlikely to be thinner at the bottom or it could not support the weight above, and if it suddenly took a step sideways where it disappears behind another stem the flower would have real problems, defying gravity being one of them. If a long leaf seems to bend over, as they often do, it must still have a logical progression with no broken lines for the veins.

FLOWER SHAPES Many flowerheads can be simplified into a basic circle, and when a circle is seen in perspective, turned away from you, it becomes an ellipse. Practice drawing ellipses as they are the magic formulae for solving a number of problems that beset the beginner. Hold a saucer up and look at it full face, imagine it is a daisy and turn it slowly on its axis so that it is flat. Just for fun, as it is a very loose analogy, lightly draw the saucer on three or four different planes and then put it down and turn its shape into a flower—a simply daisy. Now do the same with a bowl or cup and turn it into another flower shape.

Think about what happens when the basic shape is broken. For example, if your saucer of a daisy had a limp petal hanging down on one side and you pushed it back into place, it would fit back into the ellipse; it would not have become longer or thinner, though it might look that way. Perspective and foreshortening need to be observed carefully, and the various angles can be worked out in a separate drawing with guide lines made obvious.

More complex flowers, where the basic shape is not obvious, require more acute observation, but the principles are the same. If you do not understand how or why a shape is as it is, take one

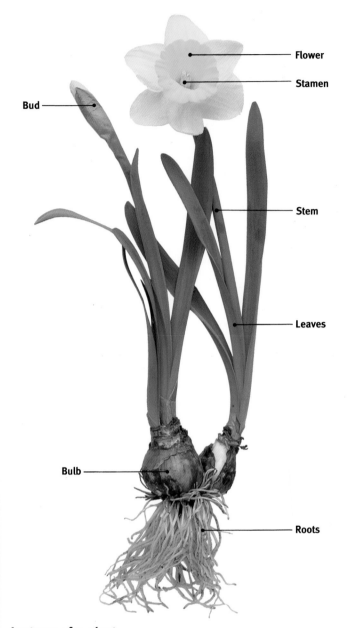

Anatomy of a plant
Familiarity with the structure of a plant, and knowing how the parts join up and at what angle the flowers grow from the stem, all give a painting credibility.

flower apart very gently and slowly and see how it is put together. Look at the different stages and see whether an older flower has the start of a seed pod developing. This sounds obvious, but for a spray on a single stem you will need to show the progression from the wide open flower at the bottom to the bud at the top.

Bell shaped

Flowers of this type follow the three-dimensional shape of a bell; the stem supports the flower from the center top, the petals fall around the axis of the stamen, which corresponds to the clapper. The shadow is deep on the inside, and there may be a curve of light to the back, inner edge.

Trumpet shaped

A lily, with its stamens protruding out like symbols of noise, makes an obvious trumpet. Many other tubular flowers start conical and then the petals flare into the familiar trumpet shape. Make sure that the petals curve into a center point, even when they disappear into shade.

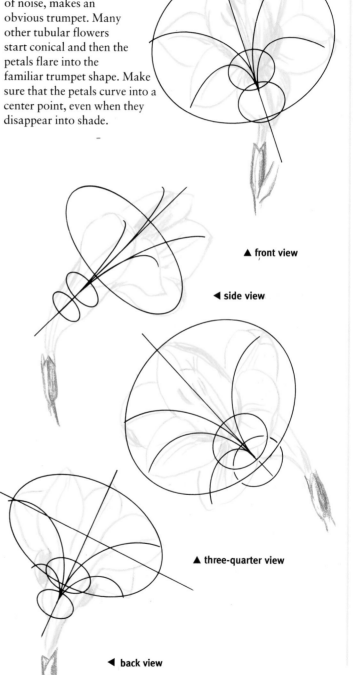

▲ front view

▶ back view

▲ side view

▶ three-quarter view

▲ front view

◀ side view

▲ three-quarter view

◀ back view

Multiheaded

Look for the overall shape of the whole cluster of flowers, a ball, cone, or something more irregular. Work out the planes of each individual flower and pay most attention to the detail of the nearest ones to you, leaving the ones away from the light source to dissolve in shadow.

Spike shaped

Even quite large flowered spikes, such as gladioli, can form an overall cone, so treat them as one shape. Note the central line of the stem and how the flowers surround it. Tackle the shading as a whole. For any view close-ups, let the brushwork indicate the individual flowers rather than painting in each one.

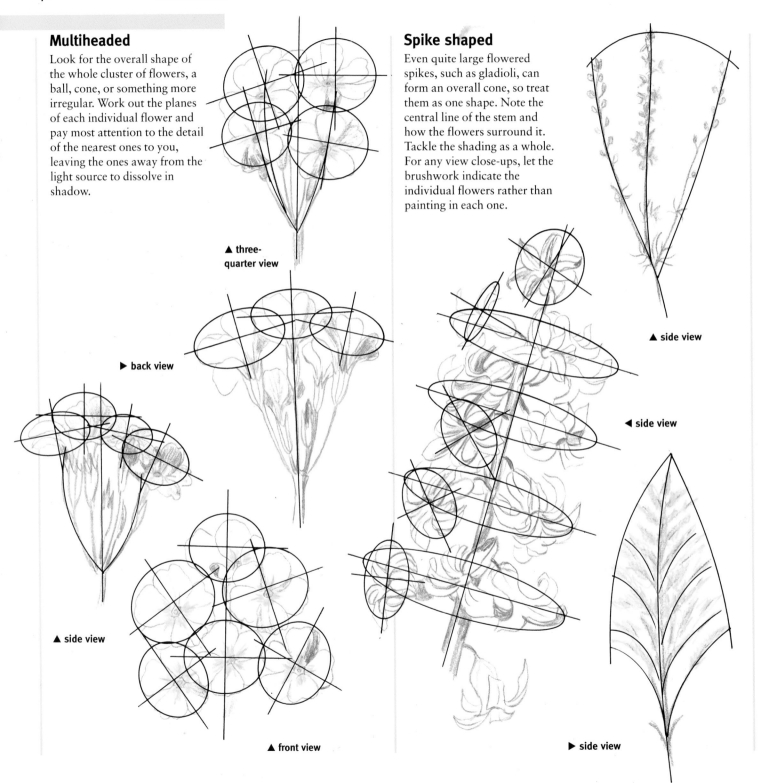

▲ three-quarter view

▶ back view

▲ side view

▲ side view

◀ side view

▲ front view

▶ side view

Rays and pompoms

In these flowers, the petals radiate out from a central point, and everything joins the stem in the middle. Turning a flat gerbera or daisy reveals ellipses, and when seen from the side, all the petals are equidistant and form rounds. The center sometimes forms a dome or pompom.

Star shaped

Simple star shapes usually have a very distinctive clear center, sometimes with a burst of stamens or a pinpoint of meeting petals. There may be a bulge or even a thin tube of petal where the stem joins the back. There are few tonal variations to the open, flat petals.

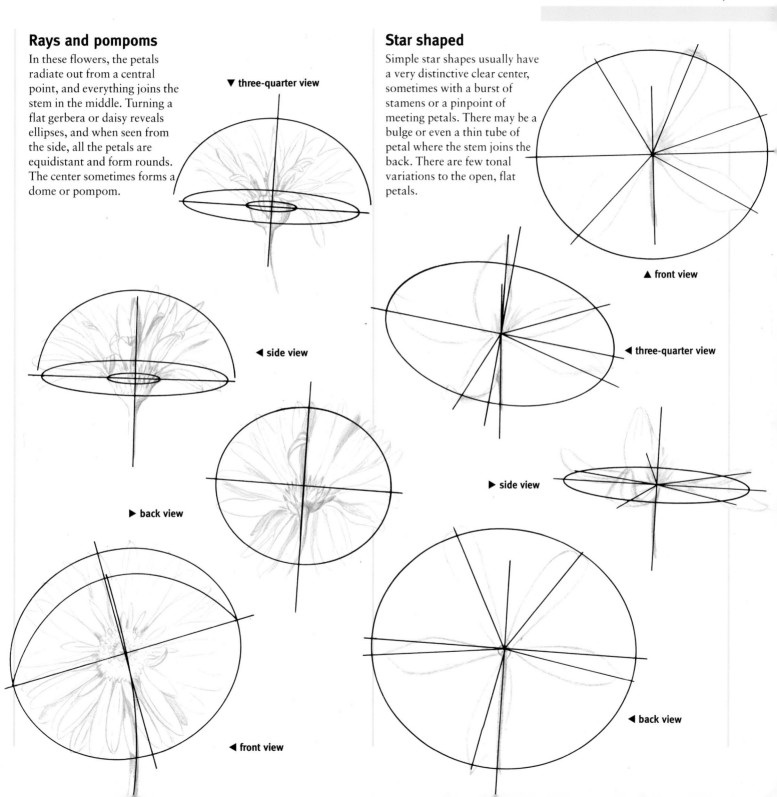

▼ three-quarter view

◀ side view

▶ back view

◀ front view

▲ front view

◀ three-quarter view

▶ side view

◀ back view

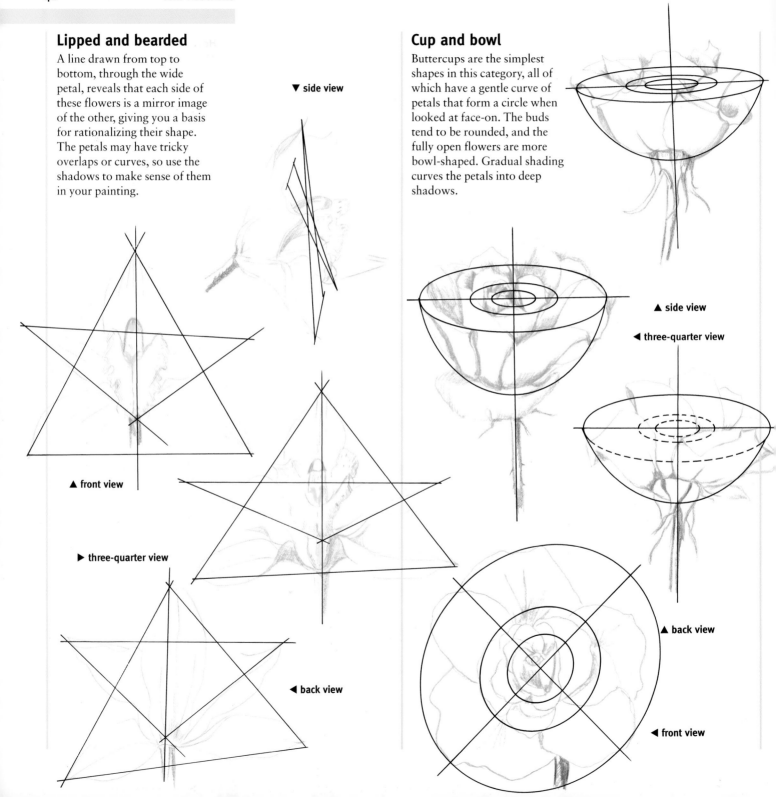

Lipped and bearded

A line drawn from top to bottom, through the wide petal, reveals that each side of these flowers is a mirror image of the other, giving you a basis for rationalizing their shape. The petals may have tricky overlaps or curves, so use the shadows to make sense of them in your painting.

▼ side view

▲ front view

▶ three-quarter view

◀ back view

Cup and bowl

Buttercups are the simplest shapes in this category, all of which have a gentle curve of petals that form a circle when looked at face-on. The buds tend to be rounded, and the fully open flowers are more bowl-shaped. Gradual shading curves the petals into deep shadows.

▲ side view

◀ three-quarter view

▲ back view

◀ front view

Basic leaf shapes

The shape of the leaf identifies the plant as much as the flowers. The subtle differences of shapes are particularly important where the color of the flower is matched; deep red flowers may be supported by a leaf tinged with maroon, while the same genus carrying a white flower may show a paler green leaf.

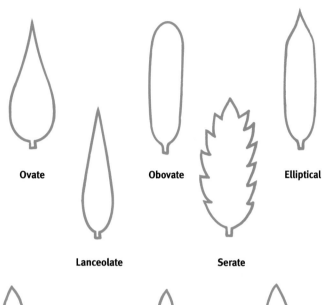

Ovate **Obovate** **Elliptical**

Lanceolate **Serate**

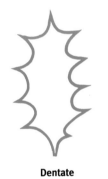

Dentate

Palmate

Pinnate

Hastate

How leaves grow on a stem

When observing leaf joints, keep in mind the function of the leaf to understand how the "plumbing" must join up and the shape should flow. If the plant is healthy, there should be no sudden breaks or impossible angles.

Alternate leaves **Opposite leaves**

Whorled leaves **Alternate (whorl)**

Overlapping leaves

Lift a red leaf of an Acer palmatum, and you see that the one underneath is green because it has not been affected by sunlight. Even where leaves are the same color, they will be varied by shadows. Similar changes of hue occur where one leaf twists over itself. Use all these color changes to indicate shape.

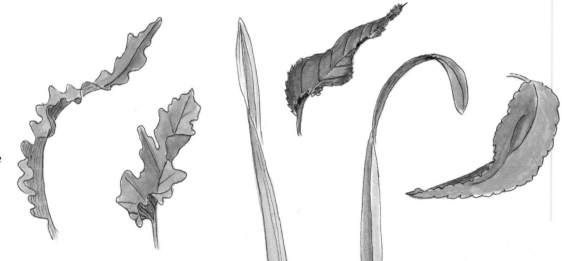

Arranging flowers

You need not become an expert florist overnight to paint flowers, but a brief explanation of the basic principles of flower arranging may come in useful.

The more formal arrangements follow well-defined rules, however uncontrived they may look. A florist usually builds the outline starting with the foliage. The height and width are fixed first, with "anchor" stems which form a triangle marking the outside limits and creating the required shape and size. No stems should ever cross and each should be angled to a central vanishing point in your mind, even if it is well below the vase in reality. Every piece of foliage and flowerhead is likewise worked in triangles. The central front, lowest point, is placed next, and the left and right centers of each side, forming another triangle. Then the flowers can be put in, working round in the same order, making triangles with the longest points.

Color and tone become the next concern. Pale colors need to be placed with care as they draw the eye to the shape. Ideally start with a spray of small white or pale flowers as the second highest point and continue it through to one side, making that the second longest point. Then do the same with another type of light flower but running through to the opposite side to balance it. Blues will recede and yellows come forward when viewed from a distance. Red, although theoretically an advancing color, can be deceptive and may not be as attention grabbing as you imagine. If it is the deepest shade it will certainly recede; it is only when yellow is added and it becomes orange that it starts to take over. Always reserve three large blooms or dense-shaped flowers to give depth to the center of the display, pushed well down into the arrangement toward the final stages, forming another triangle. All flower arrangements use odd numbers of stems, threes, fives, and sevens, and are based on exaggerations of these principles.

CONTAINERS AND VASES The container should obey the same laws of gravity as in real life. It should not appear as though it will keel over under the weight of the mass it holds. Your painting may not show a great deal of it as it may be covered with flowers and foliage, but it must still provide a solid foundation for the rest of the painting.

The shape of the container—curved or square, squat, or shapely and elegant—can form an important part of the picture;

Place the next tallest stems to one side, the third tallest to the other, and then carry through to the opposite widest points (*right*).

Basic arrangements
Mark the extremities of the triangle by placing the tallest and widest of the stems (*left*).

Fill in the triangle, remembering to push some foliage and flowers in deep so that the display is solid (*left*).

Vases
The container must take the weight of flowers without falling over, and empathize stylistically. ❶ A tall, slender vase is ideal for long stems. ❷ A rounded, pearlized vase sets off pale colors and round flowers. ❸ A tall, strongly colored jug complements gladioli and strong flowers. ❹ A solid, homely jug suggests cornflowers or nigella and daisies.

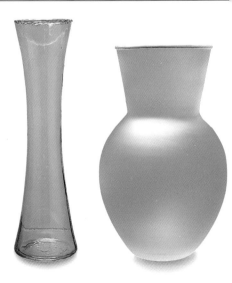

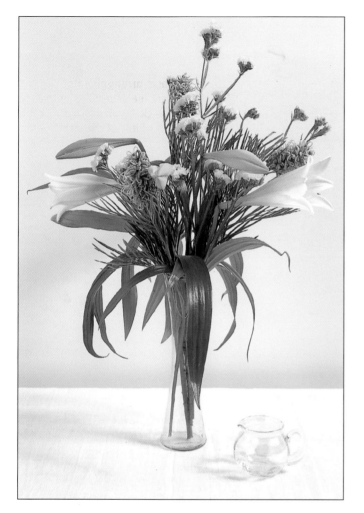

Inspiring arrangement
Matching the flowers to the container (*left*) can show the plant's character. Use props to give depth (*right*); here, glass pebbles extend the foreground. Baskets (*below*) hide water containers.

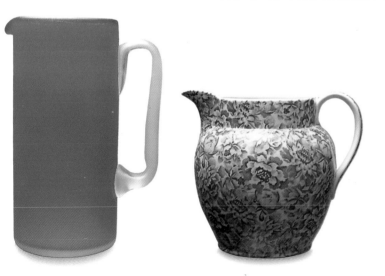

it is a sizeable and solid shape contrasting with more fragile and irregular ones. Keeping it plain is probably the best to start with. When you paint, make sure you get the ellipses right, or the perspective if it is square, so that it looks convincingly solid. And observe the shadows well so that it does not seem to be levitating from the table.

If you have chosen a patterned container, you can ignore the pattern if you wish, but as you become more confident you might try the idea of using a highly patterned vase which echoes the flowers. An Oriental vase could be filled with apple blossom or chrysanthemums that match the pattern, or a Wedgwood style used to hold a blue and white arrangement. If you do not own such vases, you could invent, making up your own design from the flowers and leaves you are painting, simplifying the motifs and picking one or two colors you want to emphasize.

Care of subject

Plants have a life of their own, so for any painting that takes longer than a couple of hours you will need to do some forward planning.

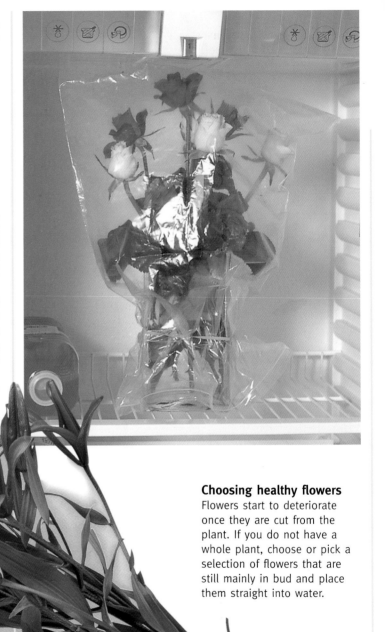

Flowers do not last well, and even when still alive they will alter, with buds opening and petals dropping while your back is turned. If you are making a study of an open flower, it is helpful to pick some buds also, so that you have a back-up. Overnight they can be kept in the fridge, covered with a polythene bag. All cut flowers need to be kept in water all the time.

Pot plants provide a good alternative, as the whole thing can be returned to its natural environment as often as required to keep the flowers fresh and the plant itself healthy. For some particularly delicate species that open two seconds after being brought into a warm room this is the only way unless you are prepared to work outdoors.

Keeping single stems or small groups of flowers fresh for close-up studies requires a little more ingenuity. The glass pipettes or vials in which cut orchids are sold can be useful for smaller, individual stems, as these can be blu-tacked to a drawing board. Oasis taped to theboard is another way of keeping sprigsfresh for a short time. So think ahead about how you are going to keep and display the flowers, and obtain them only when you are ready to devote some time to painting them.

Choosing healthy flowers
Flowers start to deteriorate once they are cut from the plant. If you do not have a whole plant, choose or pick a selection of flowers that are still mainly in bud and place them straight into water.

◀ Keeping flowers fresh

Don't keep flowers in hot sun or heated rooms, or under the heat of a lamp, as they will open fast and die quickly. You can keep flowers in the refrigerator, covering them with a polyethylene bag (*left*).

Close-up studies

The best way to learn about one flower or to do a botanical illustration is to sit at a drawing board and take time to really study your subject, but don't leave it dying without water. Place a single flower in a vial of water and tape it to the board (*below left*); alternatively, arrange small sprigs or tiny bunches in wet florist's foam before taping them securely (*below right*).

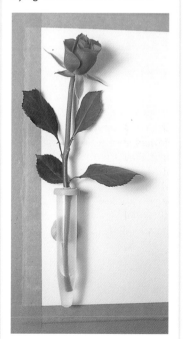

Care of Subject Check List

Cool and moist suits most plants and flowers.

- Keep flowers in their natural surroundings for as long as possible.
- Delicate spring flowers do better growing in a pot.
- Never cut or buy flowers until you are ready to start.
- Put cut flowers in a cool place overnight.
- Spray water over flowers with a fine-mist spray.

Cut the stems as you put flowers into water.

- The stems start to seal up as soon as removed from water, so recut them and place in deep water to make sure they last when arranged.
- If heat is making flowers open fast concentrate on one bloom at a time.
- If your arrangement includes buds, paint these first, before they open.

To prevent movement, keep flowers wrapped until needed.

- Put specimens in the fridge overnight, still in water, and cover with a plastic bag.
- If you are working by artificial light, use a cool daylight bulb.

Remove any vegetation from the lower part of the stems.

Working from photographs

For some artists, photographs have virtually replaced the sketchbook, though others shudder at the very idea. Photographs are a very useful aid, but they should be seen as no more than that.

You do not need to analyze something in order to snap its picture, whereas the tried and true methods of making drawings and planning the composition through rough color sketches makes you really get inside your subject and may show you different ways of developing it into a painting.

But the great advantage of the camera is that it can make records of fleeting color changes, and freeze a bud or flower at a moment in time. It can help you create an environment for a plant, showing twigs, dead leaves, or perhaps even an insect that certainly will not wait around for you to draw it. Photographs allow you to work in the comfort of your home or studio and can also help you with composition, as you will decide on the best viewpoint and arrangement as you look through the viewfinder.

But paintings done entirely from photos can look strangely flat with no sense of space. You are trying to create the impression of three dimensions on a flat surface, and using an image that is already two-dimensional will not necessarily help. Exaggerating the flowers in the foreground slightly or giving an extra misty paleness to the background features can give extra depth. When you take the photo, keep a mental note (or better still, do a sketch as well) of the things that make such a difference to the three-dimensional look of the subject painting.

A greater problem is that you may lose your way looking at a photograph, not really understanding what is happening in parts of the picture, and this may cause you to fake it. A petal may look distorted because it has blended into another flower, and the leaves may have become a confused mass, but if the subject is no longer there you will not be able to check. Take pictures from all angles so that you have a full record of the forms.

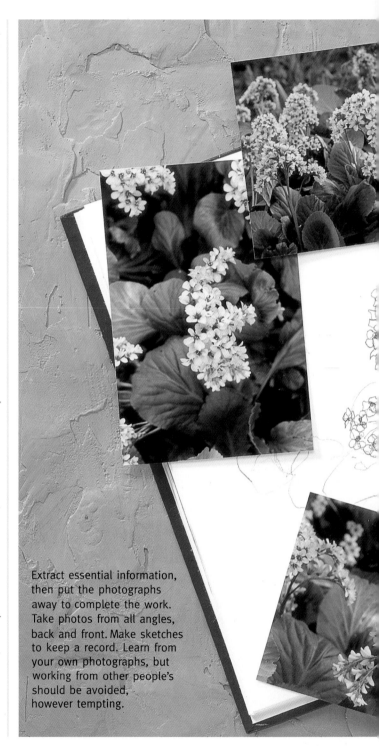

Extract essential information, then put the photographs away to complete the work. Take photos from all angles, back and front. Make sketches to keep a record. Learn from your own photographs, but working from other people's should be avoided, however tempting.

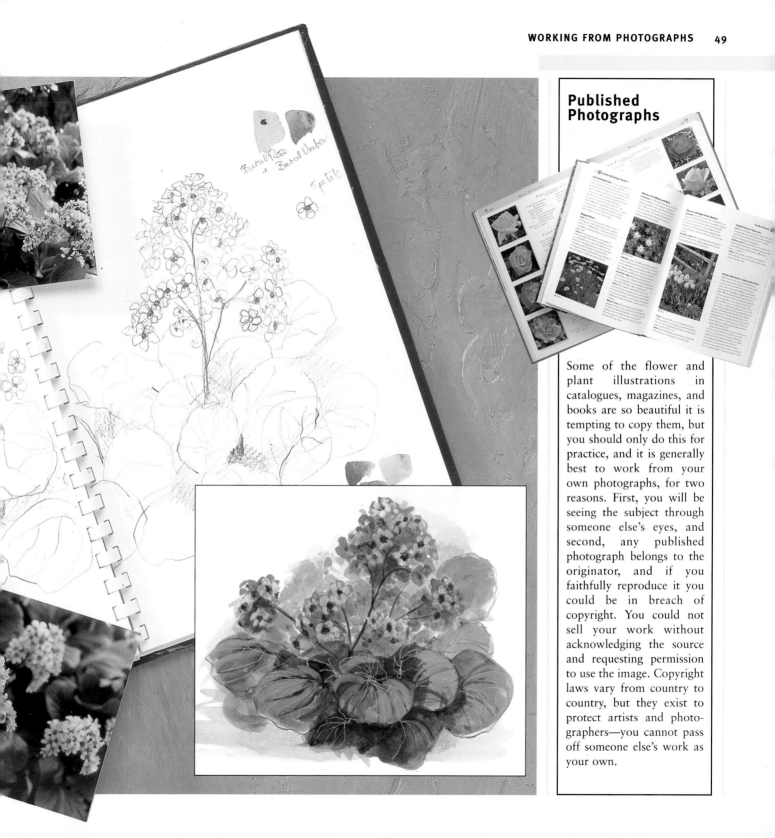

Published Photographs

Some of the flower and plant illustrations in catalogues, magazines, and books are so beautiful it is tempting to copy them, but you should only do this for practice, and it is generally best to work from your own photographs, for two reasons. First, you will be seeing the subject through someone else's eyes, and second, any published photograph belongs to the originator, and if you faithfully reproduce it you could be in breach of copyright. You could not sell your work without acknowledging the source and requesting permission to use the image. Copyright laws vary from country to country, but they exist to protect artists and photographers—you cannot pass off someone else's work as your own.

FLOWER-PAINTING TECHNIQUES

Being able to look at flowers as a loose analogy of geometrical shapes provides a good guide to perspective and supplies rules to sort out a clutter of information.

Bell-shaped flowers

A bell-shaped flower generally hangs down, attached to a curving stem at the center top, with a rounded dome that reflects light on the top, bringing the upper curve out towards you. The inside is seen as a rapidly deepening shadow, with the bottom edge catching any light in a curved reflection of the opposite edge. Take advantage of contrasting stamens to provide perspective to the depth, and round shadows away from the light source.

Color palette

Sap green

Oxide of chromium

Cadmium yellow

Winsor violet

Manganese blue

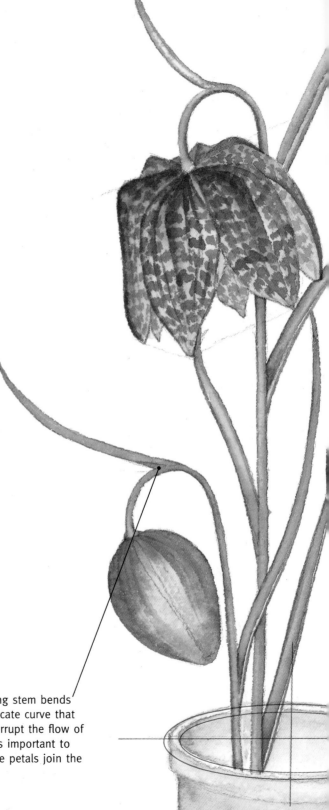

The supporting stem bends over in a delicate curve that does not interrupt the flow of nutrients. It is important to study how the petals join the stem.

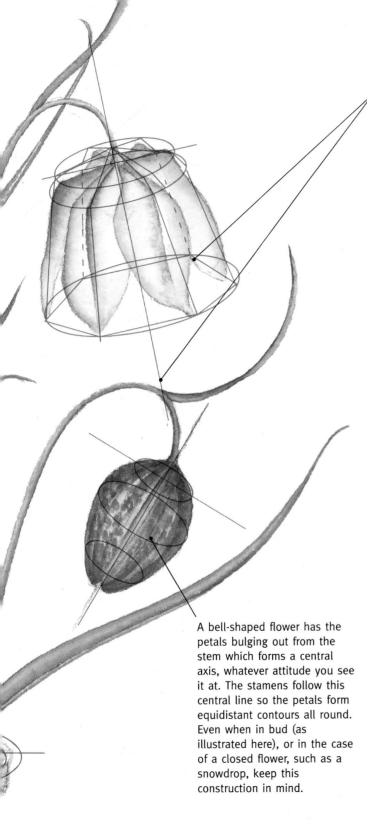

Visualising the flower as a bell makes an understandable three-dimensional form, keeping the stem as a pivot point. Shadows inside the center, where apparent, should emphasize the rounded contours. The stamens of some species may project like the clapper of a bell. Here, the central lines of the petals of the fritillaries are slightly raised before they join the stem and they have points at the lip, but the overall concept of bell-shape still applies.

A bell-shaped flower has the petals bulging out from the stem which forms a central axis, whatever attitude you see it at. The stamens follow this central line so the petals form equidistant contours all round. Even when in bud (as illustrated here), or in the case of a closed flower, such as a snowdrop, keep this construction in mind.

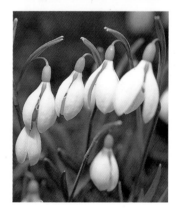

Top: *Campanula* – shows bells at every angle. **Middle:** *Erica* (Heather) – tiny close mouthed bells. **Bottom:** *Galanthus* (Snowdrop) – note stem joint.

Hellebores: oil pastel

A great advantage of this medium is that it does not crumble into dust, as soft pastels do, so there is less risk of spoiling your work by accidental smudging, and you need not bother with fixative. The classic pastel technique of blending colors by rubbing them together with your fingers does not work well with oil pastels, but colors can be mixed by laying one over another, and partially "melted" with turpentine, mineral spirits, or lighter fuel and with a brush. Serious mistakes can be similarly rectified, by removing the color with a brush or rag soaked in one of these substances.

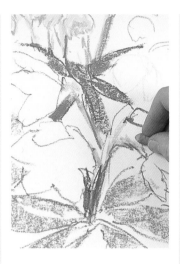

2 The arrangement of light and dark tones are an important element, so the next step is to block in some of the dark-toned green leaves. At this stage, the oil pastel is used lightly, only partially filling the grain of the paper, to allow further colors to be laid on top.

3 With dark and mid-toned greens and browns now surrounding the paler flowers, the artist works on the central group. She applies a pale pink inside the original drawn lines, leaving some of the paper white.

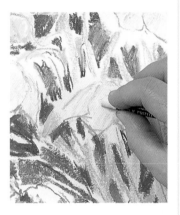

4 The same pale pink, plus yellow and a little light brown, has been used for the open flowers at the top, and now a very dark blue-green is taken around beneath the edges of the petals to accentuate them.

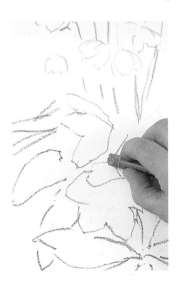

1 Starting with the larger flowers and leaves, the artist draws in the main shapes, using lighter versions of their final colors. She does not attempt to make an outline drawing of the whole arrangement, as she likes to "feel her way through" as she works.

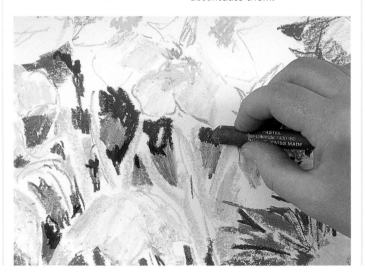

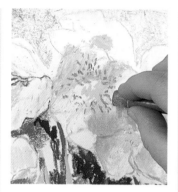

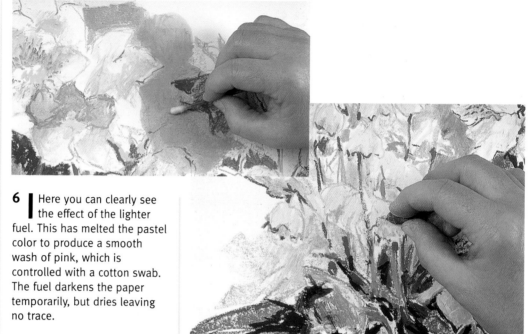

5 | A soft effect, with subtle gradations of color, was required for the petals, so pale greens and gray-blues were blended together with a brush dipped into lighter fuel. To describe the pattern radiating out from the center, short, jabbing marks are made with the side of a pastel stick.

6 | Here you can clearly see the effect of the lighter fuel. This has melted the pastel color to produce a smooth wash of pink, which is controlled with a cotton swab. The fuel darkens the paper temporarily, but dries leaving no trace.

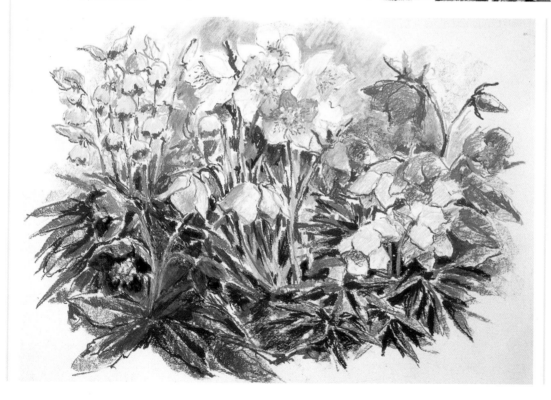

7 | The flowers are described mainly by picking out key shapes and outlines, and here squiggling lines of dark red are used for the edges of the petals. As can be seen in the finished painting (left), these were subsequently overlaid with mid-toned green to soften them.

8 | Oil pastel would not be a suitable medium for small, delicate or highly detailed studies of single plants or blooms, but is ideal for broad effects. Although there is little fine detail in this painting, the flowers are convincingly portrayed through shape, color, and relative size, and the strong tonal contrasts give life and energy to the composition.

Further Practice

One of the most important skills in painting is learning to match your media and style to the subject, so try out a variety of different media if you can. Delicate watercolor seems the ideal choice for the fragile-looking harebells, to which you would not do justice with a broad medium such as pastel. For white flowers, such as the foxglove, you could use an opaque medium, or a transparent one in combination with masking fluid, while the strong shape and brilliant colors of the crown imperial seems to suggest a flat-color approach in gouache or acrylic.

Fritillary: watercolor

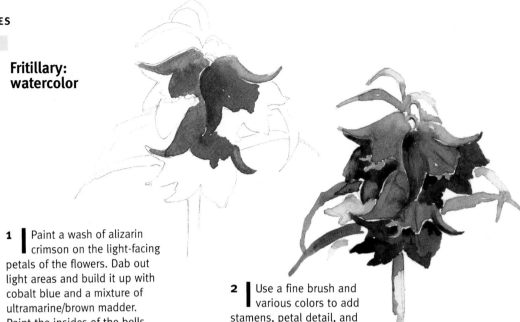

1 Paint a wash of alizarin crimson on the light-facing petals of the flowers. Dab out light areas and build it up with cobalt blue and a mixture of ultramarine/brown madder. Paint the insides of the bells with brown madder and alizarin crimson/ultramarine.

2 Use a fine brush and various colors to add stamens, petal detail, and dense paint to the inside depths.

Harebells: watercolor

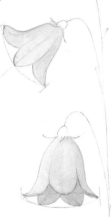 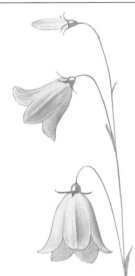 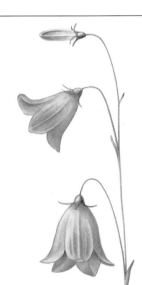

1 Start with a light pencil drawing, making sure the ellipse at the base of the flowers is correct, then lay light, slightly graded washes on the flowers. For the bud, drop a small amount of water onto the paper first, so that you can blend the colors wet-into-wet.

2 To build up the forms of the flowers, work into them wet-on-dry, using slightly darker blues. Draw the stems and bracts with a fine brush and fairly dry paint, leaving white paper for the small highlights on the calyxes.

3 Continue to build up the depth of color on the flowers, using small brushstrokes in a hatching technique, as you might with a pencil drawing. Finally, to soften the brushmarks, go over each flower carefully with clean water.

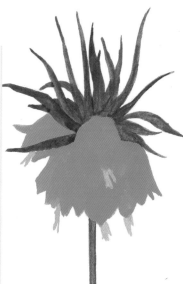

Crown imperial: gouache

1 Gouache is an excellent medium for laying areas of flat color, with little or no blending and sharp divisions between tones. Start with a pencil drawing and then lay down the middle tone for both flowers and leaves.

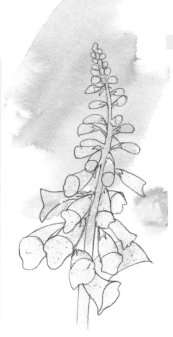

Foxglove: mixed-media

1 Masking fluid is a great help when painting white flowers in any of the transparent media. Draw the flower shapes and then fill them in with the fluid so that the white areas are protected. The pencil lines can be rubbed out, or incorporated into the picture.

2 Next, paint the lighter tones on top, still using the paint thick and opaque. It will sink into the underpainting slightly, but can be lightened further if necessary by adding another layer.

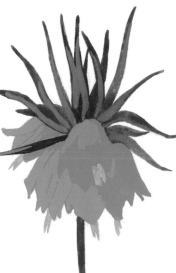

2 Leave the fluid to dry and then lay the background washes over the top. Liquid acrylic is shown here, but watercolor or thinned acrylic paint can be used if preferred.

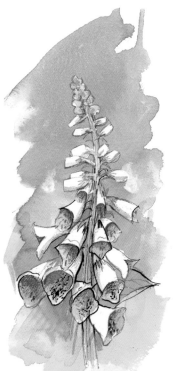

3 Finally, paint in the darker areas of the flowers, taking the new color carefully around the edges of the petals to make a strong line that describes the flowing, curving shapes.

3 The white shapes you will have once the fluid is removed can be worked into with any medium you choose. Here further ink washes have been combined with pencil and pen-and-ink drawing.

Trumpet-shaped flowers

Think of this shape as a cone. The area inside the flower is dark, with stamens at the bottom; these draw the eye in and give definition to the bottom of the cone. Keep the trumpet shape in mind to help work out the curling back and the hollow at the center. Gloxinias, shown here painted in watercolors, have this form.

"Trumpet-shaped" is a loose analogy to fix the basic shape in your mind; most flowers have bulges where they join the stem, and petals that curl back.

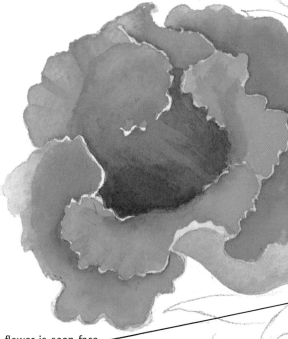

Color palette

Madder lake light

Viridian matte

Hooker's green

Carmine

Green lake light + sap green

Carmine + Vandyke brown

Carmine + burnt umber

When the flower is seen face on, the shapes evolve into concentric circles. Deepening shadow defines the depth, with the stamens providing perspective.

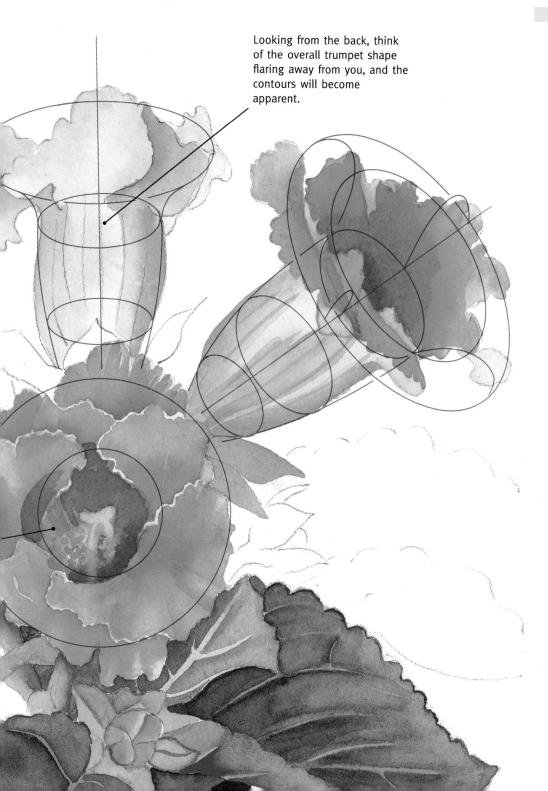

Looking from the back, think of the overall trumpet shape flaring away from you, and the contours will become apparent.

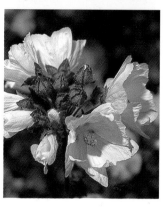

Top: *Zantedeschia aethiopica* (Arum lily) – wide, flaring trumpets. Middle: *Hemerocalis* (Daylily) – many lilies are typically trumpet shaped. Bottom: *Malva moschata* (Mallow) – multiheaded, trumpet-shaped flowers.

Daffodils: oils

Oil paints, although perhaps not quite so versatile as acrylics, can be used in a variety of ways and adapted to many different methods. The artist has evolved a personal and highly individual way of working, which involves using very thin, runny paint for the background, and applying the colors for the flowers with pieces of mat board, each one cut to the right size for the job. He also uses painting knives for small details and fine lines and for sgraffito (scratching paint away).

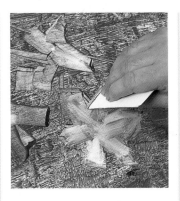

2 With the paint still wet, he uses a piece of matt board to "lift out" the shapes of the flowers, making the long, thin lines with the edge. It is important to cut the edge perfectly straight, so that it makes full contact with the surface.

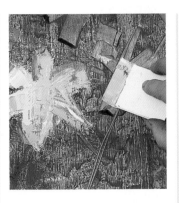

3 With the background color still slightly wet, he begins to lay on thicker paint for the flowers, using the piece of board like a spatula. The yellow does not completely cover the blue, creating a shadow effect on the petals.

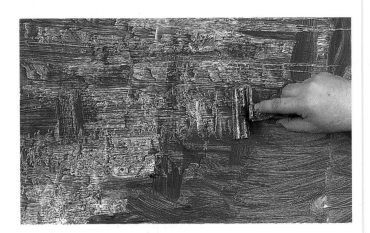

1 The background was laid with a very broad household brush dipped first into mineral spirits and then into a diluted mixture of purple and blue. He works into the paint with a roller while still wet to give it texture.

4 With more of the flowers laid in, the point of a painting knife is used to scratch lines into the still-wet yellow paint, revealing the blue beneath. The background color has to be dry for this method.

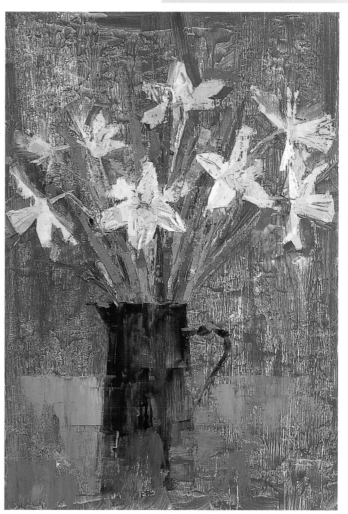

5 For the stems, the whole length of the card is used. The paint is placed with the edge of the card, and then dragged a little sideways to give the width of the stem.

6 The artist wants to avoid too much emphasis on the vase and tabletop, so he treats this area as an interplay of abstract shapes, pulling a lighter blue downward and sideways so that it partially obscures part of the vase.

7 In the final stages, some further detail was built up on the flowers with the painting knife, and a large, flat brush is used to tidy up areas of the background behind the flowers.

8 The impact of this painting stems from its simplicity. The artist's interest was in the silhouette shapes of the light-colored flowers and dark jug against the mid-toned background, and he has deliberately avoided any detail that might dilute his pictorial message.

Further Practice

The strong shapes are one of the most exciting features of this group of flowers, so they lend themselves well to a broad medium such as soft pastel, which is not well suited to small, delicate detail. If you want to stress color as well as shape you may find the method of building up in layers over an underpainting useful. You can use this with any opaque medium such as oils, acrylic, or gouache, but it is slow with oils because you have to wait for each layer to dry.

Day lily: gouache

1 | Like acrylic, gouache can be used in a layering technique, but avoid too many layers or the colors may become muddy. Gouache is water-soluble even when dry, and new applications can melt and mix with earlier ones. Begin with the background, laying a deep solution of Prussian blue. When this has dried, make an outline drawing with a yellow crayon or pastel pencil.

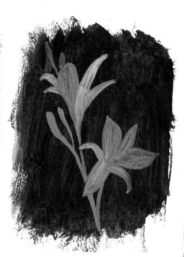

2 | Paint in the flowers with lemon yellow diluted with a little water so that it is semi-transparent. Let the brush follow the direction of the petals, allowing some of the blue to show through between each brushstroke to create shadow areas.

3 | Now use the paint more thickly and dryly to build up the highlights, blending with a wet brush where necessary. Paint the stamens and the underside of the top flower with a light reddish brown the same tone as the greenish yellow.

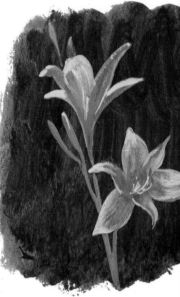

Easter lily: watercolor

1 | Establish the flower outline with a cadmium yellow/sap green wash, pushing it toward the edges. Paint the inside of the trumpet with cobalt blue/sap green mix. Tip the paper so that the paint pools in deepest shadow areas.

2 | Add touches of indigo for the underside of the petals. Paint stamen in strong cadmium yellow.

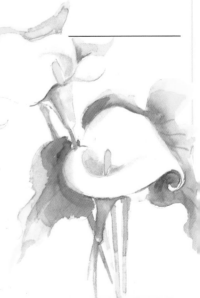

Hippeastrum: acrylic

1 You can increase the strength of color by building up over a brilliantly colored underpainting, or alternatively by laying an underpainting that is the complementary of the color you are aiming at. The first method is used here. Start with a drawing, then lay a transparent yellow wash over the whole area.

2 Do not mix the colors with white at this stage, as this will dull down reds as well as making them opaque. Paint the flowers with rich reds such as cadmium red and crimson, unmixed and diluted with just enough water to make them workable.

3 Gradually begin to build up the forms by working over the underpainting with both darker and lighter versions of the colors. Take care not to dull the reds too much, and use white sparingly.

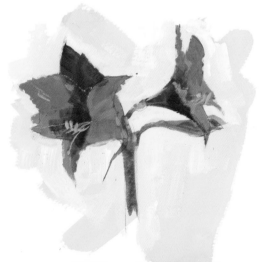

Lilies: soft pastel

1 Because the edges of the leaves are white, a background is needed to show them up. This can be added last, but you will need an indication of where to put it, so begin by drawing in the outlines of the petals with pastel pencil or charcoal pencil. Next, start blocking in the main colors of the leaves, flower, and bud.

2 Continue to build up the colors, blending them together with your finger to mix them and soften edges where necessary. To show the shadowed areas of the leaves, don't be afraid to use strong, dark colors such as ultramarine, and hard tonal contrasts.

3 Complete the flower before working on the background. For this, use a masking technique to achieve the effect of the wavy petal edges. Hold a piece of torn paper down on the surface so that the edge of the paper aligns with the edge of the petal, apply some pastel color over the background and paper and rub it in with your finger, then remove the paper to reveal a crisp white edge. You can work right around the petals in this way, using a different randomly torn piece of paper each time, and then soften some of the edges so that they blend into the background.

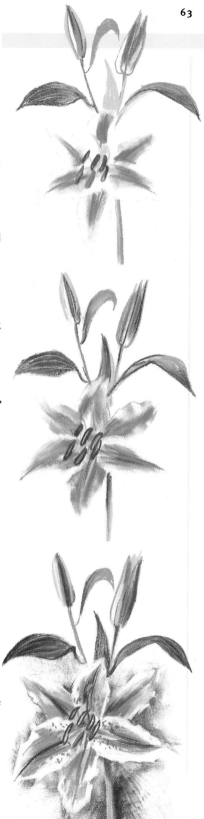

Multi-headed flowers

Many flowers are multi-headed, grouped on a single supporting stem. Analyzing the shape helps to sort out the complexities of shadow; if the blooms are tiny, indicate the mass and concentrate on some foreground flowers for detail. Here, Rhododendrons are painted in acrylics, and a painting knife is used to show the essential elements.

Color palette

Cadmium orange

Cerulean blue

Crimson

Ultramarine blue

Cadmium yellow

White

Sepia (acrylic ink)

The further away the clump is, the less individuality the flowers will have. A few contour lines and picked-out highlights may be sufficient.

The prominent planes and angles, broken by the lines and dots of the stamens, show enough of the character of the flower for it to be recognized.

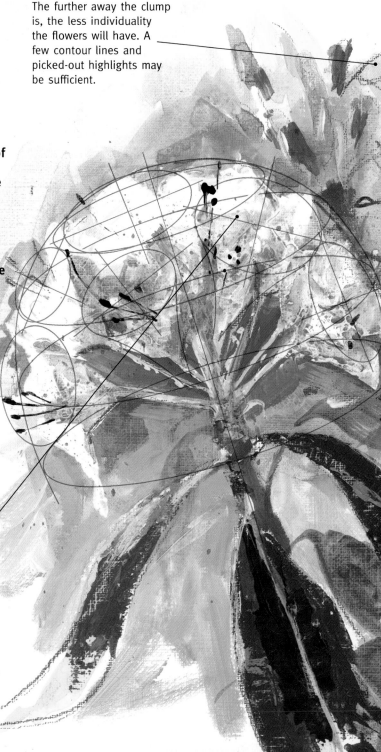

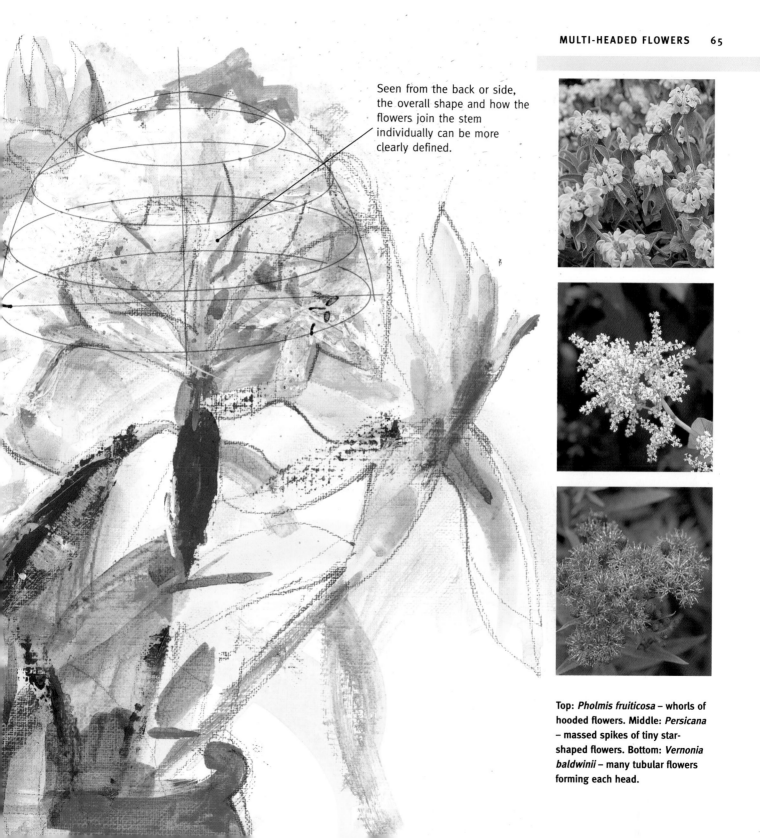

Seen from the back or side, the overall shape and how the flowers join the stem individually can be more clearly defined.

Top: *Pholmis fruiticosa* – whorls of hooded flowers. Middle: *Persicana* – massed spikes of tiny star-shaped flowers. Bottom: *Vernonia baldwinii* – many tubular flowers forming each head.

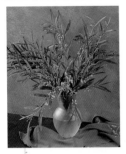

Mimosa: watercolor

The only restriction watercolor places on the artist is that, because it is transparent, you cannot lay light colors over dark ones. Apart from that, it can be used in many different ways and provides a fertile field for personal experimentation. The artist has used several rather interesting techniques for this painting, including scattering salt into wet paint, pushing plastic wrap into it, pulling out color with a twig, and applying paint with her fingers.

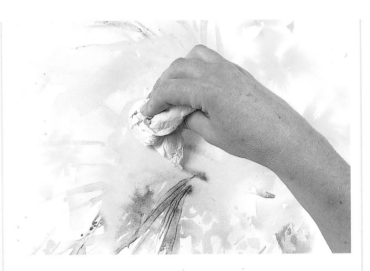

2 She works with the board at a slight angle, but sometimes during the painting process she picks it up and tilts it to encourage the paint to flow in a certain direction. Any unwanted pools and puddles of paint are lifted out with kitchen paper.

3 For the fine lines of the stems, the wet paint is pulled out with a sharpened piece of twig. The twig was also used for the leaf centers, creating a linear indentation into which the paint has flowed to form a dark line.

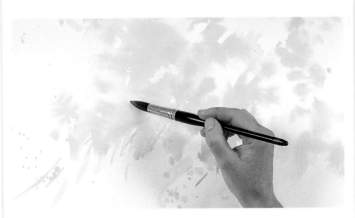

1 No preliminary drawing is made. The artist spends some time simply looking at her subject, getting the feel of the colors and shapes. She then loads the paper with water, and begins to drop in color, starting with the yellow.

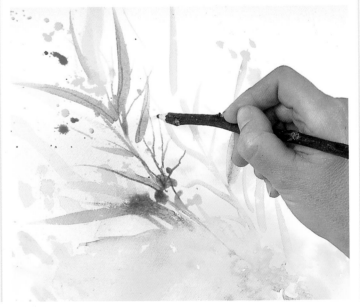

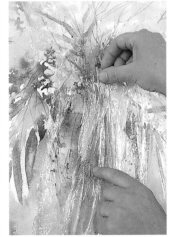

4 | To imitate the fluffy texture of the tiny flowers, salt crystals are dropped into wet paint. This causes the paint to run outward, forming small fuzzy-edged circles of lighter color.

5 | The paper is now less wet, allowing finer definition with darker colors. A large, well-loaded brush is used to pick out some of the shadows and dark leaves, thus emphasizing the flowers.

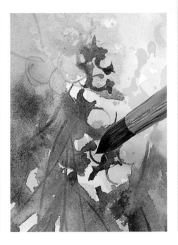

6 | To achieve the effect of the stems in the clear vase, the whole shape was first thoroughly wetted, and a strong blue loaded on. A piece of plastic wrap was pulled into long creases, pressed down, left for about twenty minutes, and then removed. The pigment gathered under the creases and dried to form lines.

7 | For the small flowers in the center, silhouetted against the light background, a finger is used to dab on paint straight from the tube, a simple and effective method.

8 | In the foreground, the artist has encouraged one of the semi-accidental effects of watercolor, its tendency to form backruns. This adds to the impression of freshness and spontaneity that expresses the subject so well.

Further Practice

This type of flower has a main head made up of near-identical component shapes. Sometimes the individual florets are small and tightly clustered, as in the lilac flower and the viburnum shown here. In other cases, for example the nerine, the florets are larger and more loosely bunched. In either case, look for the main shape first and emphasize the form by giving the nearer flower a sharper focus.

Forget-me-not: watercolor

1 Use cerulean blue for lighter, distant flowers, and cobalt blue for closer, brighter flowers. Drop dots of paint to create flower heads. Allow some of the dots to blend and add touches of permanent rose.

2 Add detail to some close flowers. Use cadmium yellow for a few flower centers. Link all flowers with threads of stems of sap green.

Nerine: watercolor and oil

1 The individual flowers that make up the head are elegant and intricate in shape, seeming to ask for a semi-linear treatment, and the combination of watercolor and pen drawing suits them well. Pen and wash is a traditional technique, much used in the 19th century for both landscape and flowers. Make a pencil drawing first, and then lay light, loose pink washes.

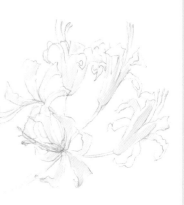

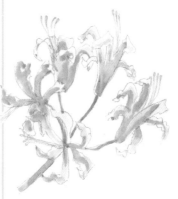

2 Build up the colors, working darker pinks into the original washes wet-into-wet so that colors blend softly, giving a fresh, free feel. Do not worry if colors slop over the drawn lines, as the ink drawing will provide all the crisp definition you need.

3 Now use a pen and black ink to complete the image. As with the watercolor washes, try not to be too precise; instead aim at a rather sketchy quality. Avoid making the lines too uniform; try to vary the width of line from thick to thin by applying heavier pressure in some places than others.

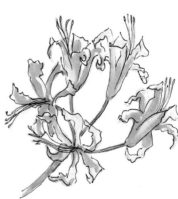

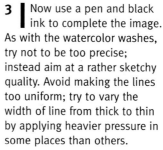

Viburnum: oils

1 Oil paint, although lacking the obvious delicacy of watercolor or colored pencil, can produce lovely, subtle effects, and you can vary the consistency, building up from thin, almost wash-like paint to thicker, more decisive brushstrokes. Start by blocking in the main shape with paint thinned with turpentine, pulling out the brush toward the edges to give them a soft, blurry quality.

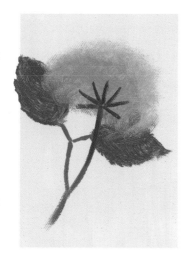

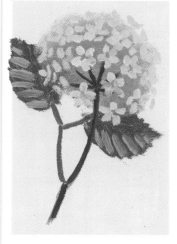

2 Now use the paint more thickly, and form each petal with just one brushstroke. You may need to experiment with different shapes and sizes of brush before you can do this with confidence. A medium-sized filbert shape is a good choice for flower petals.

3 For the final stages, concentrate on crisping up the painting, laying on thick strokes of white where the petals catch the light. The earlier layers of paint will not have dried, and the white will mix into the pinks beneath to soften the effect. This method is called working wet-into-wet.

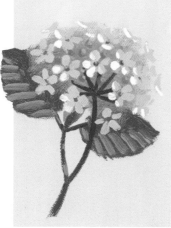

Hydrangea: pastel

1 The choice of paper color is important in pastel work, as it is seldom possible to cover the paper completely, and small patches and flecks will show between and around the pastel marks. If you choose a color that contrasts with the subject you can use a method known as vignetting, in which the paper provides the background, with no pastel color added. The dark green shown here is an excellent foil for the brilliant colors of the flowers, making them appear brighter by contrast. Begin with a pastel outline drawing, using one of the colors in the subject.

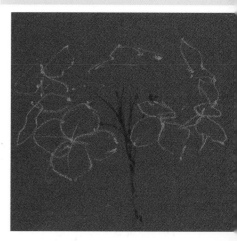

2 Making broad hatching strokes with the blunt tip of a pastel stick, begin to establish the "key" color of the flowers and the base color of the leaf. Do not work too heavily, as this would fill the grain of the paper, making it difficult to lay more colors on top.

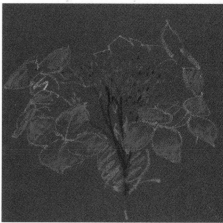

3 Now lay on both darker and lighter colors to build up the forms. Where you want colors and tones to blend softly, simply lay one firmly on top of the other; this will blend and mix them without the need for finger-blending. Finally, use the sharp edge of a dark pastel stick to emphasize some of the petal edges, and make short, jabbing marks for the stamens.

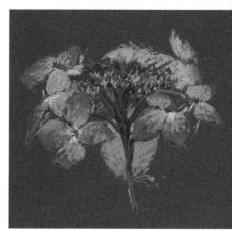

Spike-shaped flowers

Spikes are usually made up of small flowers. They are best thought of as an inverted cone. Keep the line of the stem in mind as a framework, even when you cannot see it. This pencil drawing of Gladiolus shows the triangular shape; note how the pivot of the flowers on the stem is shown by ellipses, and how the petals fall to a central joining point.

Color palette

Pinks and yellow

Greens

Mauve and blues

The ellipse of the flower is seen juxtaposed with the stem. The higher up the spike the flower is, the smaller it is.

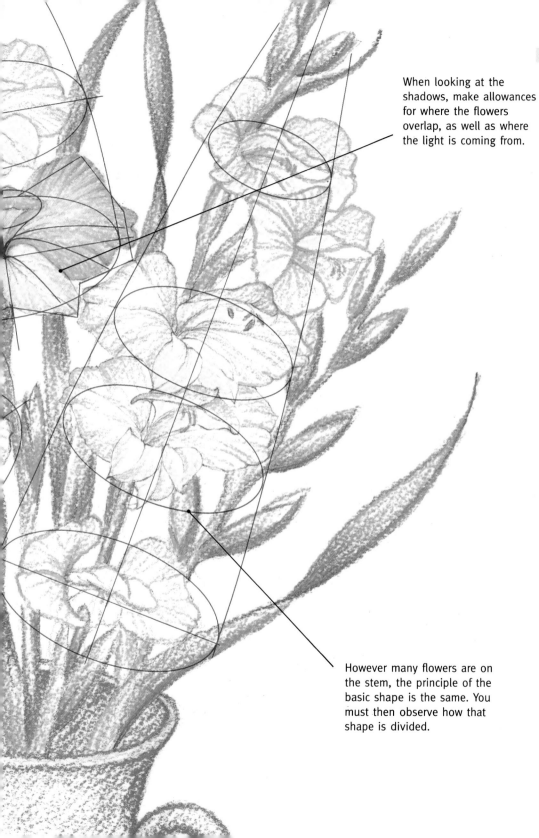

When looking at the shadows, make allowances for where the flowers overlap, as well as where the light is coming from.

However many flowers are on the stem, the principle of the basic shape is the same. You must then observe how that shape is divided.

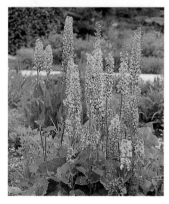

Top: *Veronica virginica* – close-packed star-shapes sporting long anthers. Middle: *Physostegia virginiana* – neat hooded and two lipped flowers. Bottom: *Ligularia* – narrow spires of daisy (ray) flowers.

Hyacinths: acrylics

Acrylic is a highly versatile medium that can be used at any consistency from thin and transparent, like watercolor, to thick and juicy, like oils. For this painting the artist has used an oil-painterly technique, working on canvas, but rather than the oil-painter's bristle brushes, he has worked with one of the synthetic types designed for acrylics, plus a Chinese brush and a small sable.

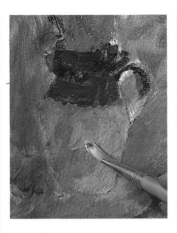

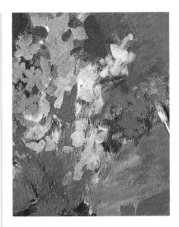

2 Acrylic dries very fast, which means that colors cannot easily be blended and merged into each other. The artist makes the most of this characteristic, laying colors close in tone side by side and over one another to achieve rich effects.

3 The blue flower was painted first as a dark blue shape in fairly thin paint, and now a lighter blue is used more thickly to make the shapes of the petals. Each petal is laid on with one stroke of the brush, with no hesitation.

4 The white flowers have been built up with thick paint, but with the minimum of detail. The stem now being painted, together with the shape formed by the petals as they meet the dark background, is all that is needed to describe their shape and structure.

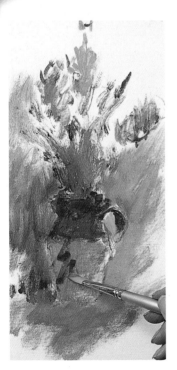

1 Rather than making a preliminary pencil drawing, the artist began with a few brush lines sketching the outline of the pitcher and flowers. Next, he lightly scumbled on some background color, and now begins to establish the shape and color of the pitcher.

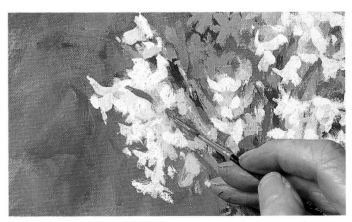

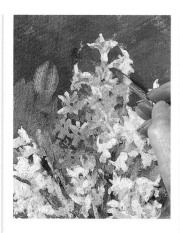

5 To define and sharpen the edges of the pink flowers, red background color is "cut in" around them. Acrylic becomes slightly darker as it dries, so it is seldom possible to repeat a color exactly, but in this case it does not matter, as the background is not an overall flat color.

6 The long-haired sable brush used for the fallen petals, called a rigger, is specially designed for fine detailed work. The same brush has been used for the highlights on all the flower petals.

7 In any opaque painting medium, it is usual to work up to the lightest tones, with the brightest highlights that give additional sparkle to a painting added last. Pure white is applied, again with the rigger.

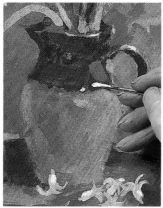

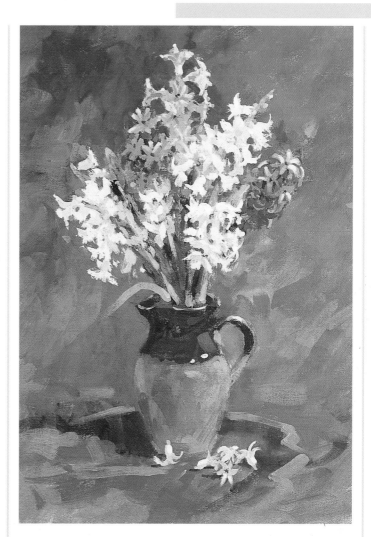

8 Tall flower arrangements often need some foreground interest, and here the group of fallen petals, together with the suggestion of drapery around the pitcher, provide a good balance for the flowers to form a satisfying composition.

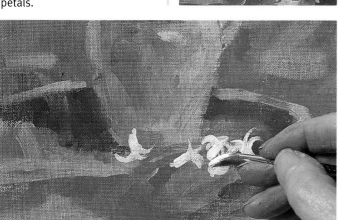

Further Practice

Although the flowers in this group vary, they all have the same basic shape, that of a tapering cylinder, which you need to draw before starting in on the florets that make up the flower. Half-close your eyes to cut out detail and reduce the main shape to a silhouette. Draw this first, then look at the small components of the shape, taking care to follow the line of the stem through the whole shape.

Bottlebrush: watercolor

1 This flower is formed from a series of spike-like stamens growing out at an angle from the main stem. You could represent it well with any drawing medium, such as colored pencil, but watercolor is equally suitable provided you have a good small brush or one of the long-haired small brushes called a rigger. Before you begin to put on color, use masking fluid to block out the stamen ends. The small white blobs and dots will add a touch of sparkle.

2 Paint the stem first, so that you don't lose sight of it, then use a small brush and strong red to create the mass of tiny stamens. Add a second layer, building up the depth of shadows by mixing some brown into the red. Finally, when the paint is dry, remove the masking fluid by rubbing with your finger or a plastic eraser.

Delphinium: watercolor

1 Dampen the flower shapes and drop in cobalt violet, ultramarine, ultramarine/phthalo blue and alizarin violet. Allow the colors to blend slightly and drop in more as they dry.

2 Use stronger paint and a fine brush to build up the flower shapes, retaining the haze of the blues. Sap green for the leaves

Mullein: watercolor

1 Paint the flowers in various mixes of Naples yellow/lemon yellow. Drop water in to lighten upper edges of flower. Pick out stamens in brown pink. Add Naples yellow/cobalt green for shadowed petals.

2 Fill in the main and side stems in cobalt green. Allow it to mix occasionally with the yellow.

Red-hot poker: indented line and colored pencil

1 | This type of flower can benefit from a degree of generalization, with the main shape emphasized at the expense of detail. You might like to try the technique of "white line" drawing, in which you make indentations in the paper, and lay colored pencil or oil pastel on top. The first step is to make a drawing, which you then trace. Fix the tracing to a piece of smooth but not thin paper (cartridge paper is ideal) then go over all the lines firmly with a fine ballpoint pen.

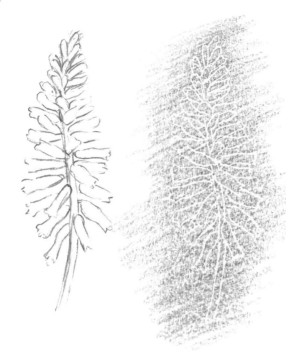

2 | The pressure of the pen will have given you a "blind" drawing consisting of linear indentations. Go over the paper with colored pencil and you will see your drawing begin to appear.

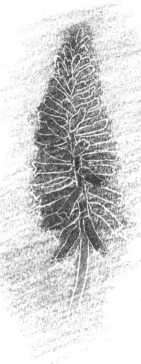

3 | The more solidly you put on the color the more strongly the white lines will show, so you can bring parts of the drawing into sharper focus by increasing the pressure.

Asphodel: watercolor and ink

1 | If you were painting these flowers in a garden or as part of an arrangement you could simply suggest them by means of shape alone, but for a close study you need to engage with the detail. This would be difficult to handle with a broad medium such as pastel or oil paint, but pen and wash, which combines painting and drawing, is ideal. Make the pen drawing first, using waterproof ink so that the subsequent washes do not cause it to run.

2 | Lay light washes of first gray and then a reddish brown. Do not overdo the painting, as this type of work is essentially a tinted drawing.

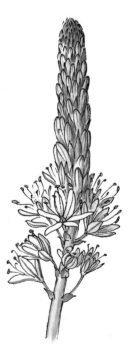

3 | Build up darker red-browns at the top and on some of the closed florets to accentuate the overall shape and form, and paint the stem in light green. The important thing with this style of drawing is to keep both pen work and washes fairly free, as over-precision can cause the rendering to lose its liveliness.

Rays and pompoms

A ray is a simple ring of petals sometimes with a domed center. This watercolor study of sunflowers demonstrates how the artist uses shadows to give body to flat geometric principles. Pompoms are similar in structure to rays. Some flowers may not make a complete globe, but thinking of it in this way will help you sort out the angles of all the petals and where the light should fall. Some pompoms are formed by tiny flowers.

Viewed from the side, note the foreshortening of the petals. Keep the concentric circles in mind to help you master the perspective.

Color palette

Cadmium
yellow lemon

Cadmium
yellow light

Cadmium
yellow deep

Burnt umber

Vandyke
brown

Sap green

Olive green

Ultramarine
blue

Yellow ocher

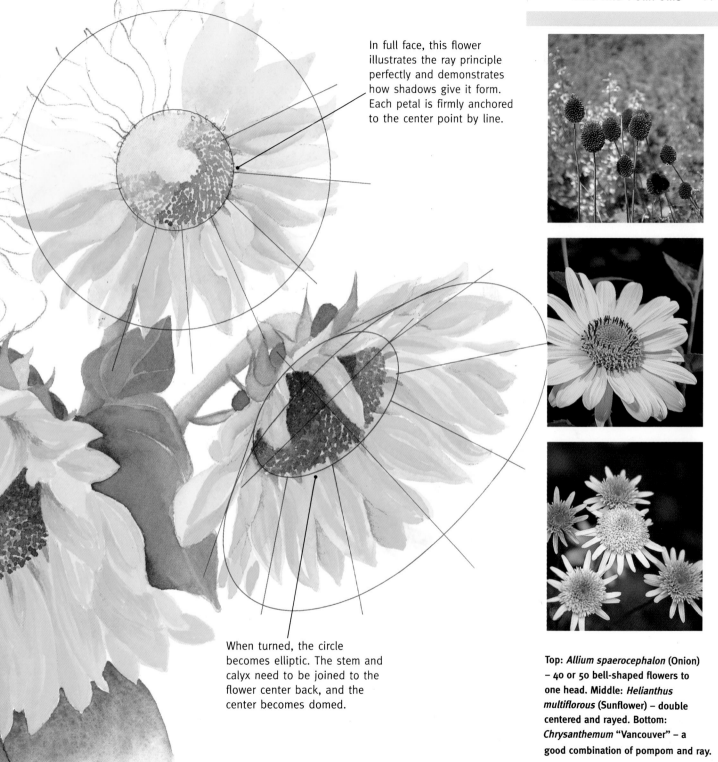

In full face, this flower illustrates the ray principle perfectly and demonstrates how shadows give it form. Each petal is firmly anchored to the center point by line.

When turned, the circle becomes elliptic. The stem and calyx need to be joined to the flower center back, and the center becomes domed.

Top: *Allium spaerocephalon* (Onion) – 40 or 50 bell-shaped flowers to one head. Middle: *Helianthus multiflorous* (Sunflower) – double centered and rayed. Bottom: *Chrysanthemum* "Vancouver" – a good combination of pompom and ray.

Asters: soft pastel

Small multihead flowers like these look best as a massed group; making a study of an individual flower would be good practice, but would lack impact as a painting. The artist has chosen soft pastel, an ideal choice, as it allows him to make expressive lines as well as building up rich colors. When working in this medium, remember that you can mix and blend colors simply by laying one over another. You can also rub colors together with your fingers for soft effects, but too much of this kind of blending can produce a dull and bland result.

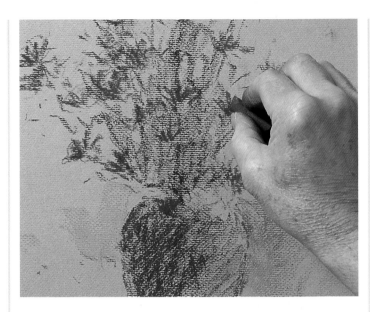

2 A little color has been applied to the background, using the side of a short length of pastel, and he now sketches in the flowers and stems using the edge of the pastel tip. Side strokes are best for covering large areas, and point strokes for detail and fine lines.

1 Never make a preliminary drawing for pastel with pencil, because it repels the soft color. You can use charcoal, or simply indicate the main shapes with the pastels, as the artist has done here.

3 Here a blending tool called a torchon is employed to spread the color, filling in the gaps between strokes. The same diagonal hatching method is used as for the strokes so that the linear quality remains consistent.

4 For the area of shadow behind the vase, several colors have been laid down adjacent to and over one another, and a finger is used to blend them lightly together and soften the lines.

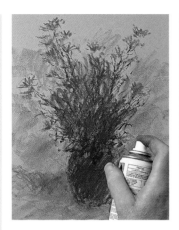

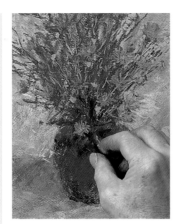

5 There is now quite a thick build-up of color, which has filled the grain of the paper. This makes it difficult to lay more colors on top unless the work is first sprayed with fixative. Fixative is often used at stages throughout the painting.

6 Because the pastel has been fixed, further color can be applied to the vase, and black is used to increase the depth of shadow beneath the overhanging flowerhead.

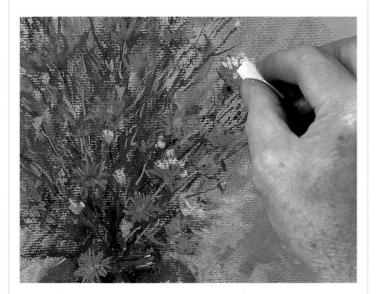

7 Small details, highlights, and color accents should be left until last or there is a danger of accidental smudging.

Again the side of the pastel tip is used to make linear white highlights.

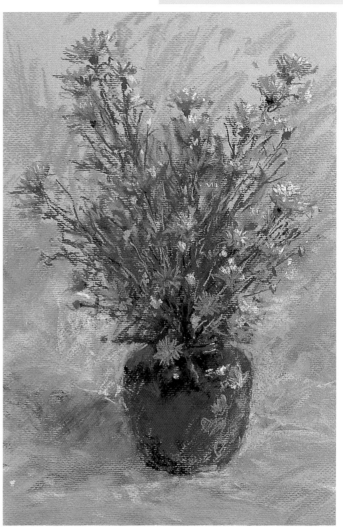

8 Although some of the background flowers are merely suggested with directional lines of color, the portrayal is convincing and accurate, and the varied pastel marks create a lively impression in keeping with the subject.

Further Practice

This flower shape suggests a good many different methods and interpretations depending on whether you like bold, broad effects or fine detail. If the former, try oil pastel or thick acrylic applied with card or a knife—this also creates attractive texture contrasts that will enliven your work. If your interest is botanical detail, there is no better medium than watercolor, but you will need to perfect your control of the paint, using the traditional dry-brush method rather than the splashy wet-into-wet approach favored by many of today's landscape painters.

Sunflower: watercolor

1 Wash lemon and Indian yellow mix into each petal. Add water to push paint to the edges. Mask out highlights on the flower center. Add darker leaves with Indian yellow/raw sienna paint.

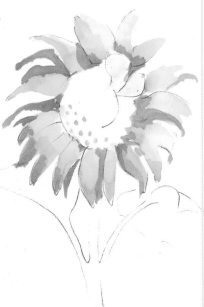

2 Dampen the center. Paint a wash of Indian yellow and burnt umber. As it dries, add burnt umber to the darker parts and burnt umber/alizarin violet to the darkest. As it dries, wash dark paint into shadow areas of the petals.

Gerbera: oil pastel

1 This bold, simply shaped flower calls for an equally bold treatment; oil pastels are a good choice. Block in the shape, using two or three different shades of red and pink, and letting the pastel marks follow the direction of the petals outward from the center.

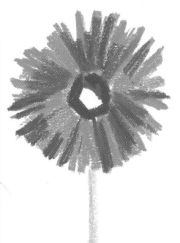

3 Lighten the nearest petals further, then use a dark color and finer lines to show the way the petals narrow as they gather in at the center. To suggest the texture of the short, massed stamens, lay more color in the center and scratch away again.

2 Remember that not all the petals are on the same plane. Some are in front of others, forming cast shadows on those behind, so begin to build up the lights and darks. For the flower center, try a technique called sgraffito, which involves laying two or three colors on top of one another and then scratching into the top layer with a blade.

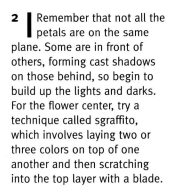

Chrysanthemum: watercolor

1 For detailed botanical studies in watercolor, you want to avoid the colors running together, so the best method is the one known as dry brush, in which you use the minimum of paint on the brush instead of loading it fully, as you would for washes. The first stage is to lay an overall pale yellow, which you will initially reserve as the highlight color. It is vital to keep both brushes and water scrupulously clean, especially when working with yellow.

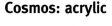

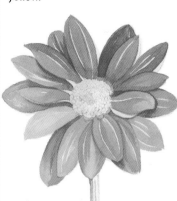

2 Observe where the highlights are to be, then take a mid-toned red around them, working carefully to the edges of each petal. Leave this to dry, then increase the strength of color on the petals at the back, and make tiny dots with the tip of a small brush for the flower center.

3 Picking up a small amount of paint on a just-damp brush for each stroke, continue to build up the density of color, achieving blends and tonal gradations by laying strokes side by side. It is wise to have a rag to hand so that you can dry the brush after washing it. Take a little red over the yellow highlights; they will still remain lighter than the surrounding reds because you have laid on fewer layers of paint.

Cosmos: acrylic

1 Using acrylic gives you a chance to introduce texture as well as a variety of color effects. It is also ideal for fine linear brush drawing. Start with a pencil drawing and then lay an overall wash of transparent acrylic (thinned with water, and with no white).

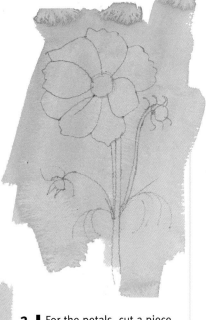

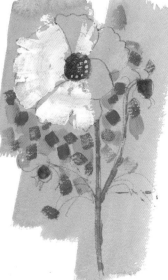

2 For the petals, cut a piece of board or plastic (old credit cards are ideal) to a suitable shape, mix up some thick white, and pull it across the shapes from the center outward. For the background, use a square-ended brush to make separate marks. This is the first stage of producing a broken-color effect to make the area more interesting.

3 Continue to build up the flower with both board and brushwork, then introduce more colors into the background before defining the stem and buds with dark green and a fine brush. If you prefer, you could use pen and colored ink for fine-line details, but avoid making hard lines around each petal.

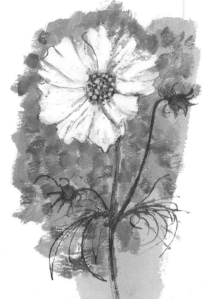

Star-shaped flowers

Although the star shape is one of the least complicated shapes when seen individually, star-shaped flowers often grow in clusters, so it is essential to sort out the basic geometry in your mind. The petals may be pointed, but the similarity is not so obvious when they are rounded or frilly. The flat centers are very clear (Black-eyed Susans) and sometimes have sparkling stamens sprouting from the middle, as with Sedums, some Malus and Choisya. Some Narcissus have a small cup or eye in the center, but the shape conforms to the principle of a simple star.

From the back, the sepals are equidistant around the center joint to the stem, which usually forms a bulge. In some cases, a small tube of furled petals opens to a star shape.

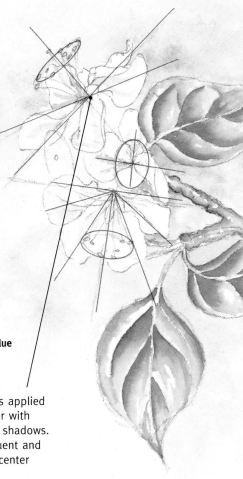

Color palette

Rose madder

Davy's gray

Sap green

Manganese blue

Vandyke brown

Cadmium yellow

Here the star shape is applied to a flat-planed flower with few contours to form shadows. The petals are congruent and radiate from a small center point.

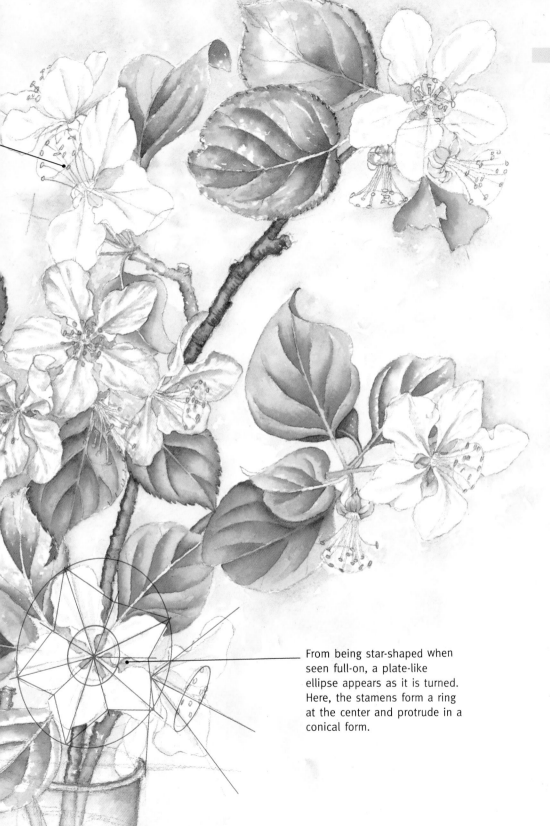

From being star-shaped when seen full-on, a plate-like ellipse appears as it is turned. Here, the stamens form a ring at the center and protrude in a conical form.

Top: *Rosa rugosa* – a simple five petalled formation. Middle: *Lindheimera texana* – showing three more tiny stars in the center. Bottom: *Anemone hupehensis* – simple petals but more complex center.

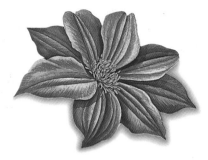

Clematis: mixed-media

For this beautiful and richly colored botanical study, worked from a combination of photographic reference and sketches, the artist has chosen watercolor, the traditional medium for such paintings, but has used this hand-in-hand with pencil and a more modern medium, water-soluble colored pencil. She has also brought in touches of opaque gouache, which mixes well with watercolor, and is often employed to strengthen and emphasize certain areas. She has used only two sable brushes throughout: a No. 3, and a No. 2 for the stamens.

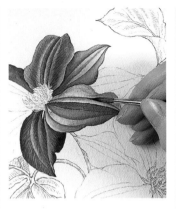

2 In pure watercolor work, it is usual to restrict the drawing to outline so that it does not show through the transparent color, but in this case the pencil drawing will form part of the work, so she builds up the tones with firm hatching and crosshatching, keeping the pencils very sharp by continued use of a scalpel.

3 In the early stages of the drawing, she was concerned with placing the center of each flower because when she lays on color she likes to work outward from the center. She uses pure watercolor at this stage, making a series of fine, slanting brushstrokes that express the texture of the petals.

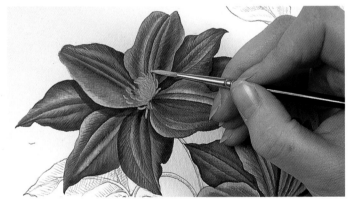

1 Before laying on color, the artist begins with a detailed monochrome drawing made with HB and B pencils. She looks closely at the structure of the flowers, the angle of the leaves, and the growth habit.

4 Because watercolor is transparent and must be worked from light to dark, it would not be possible to paint the yellow stamens over the purple. Opaque gouache will cover a darker color, and also gives a texture that imitates that of the stamens.

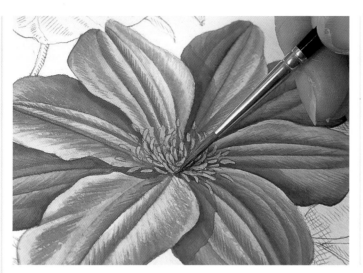

7 The touch of yellow for the background was produced by using the shavings from a yellow ocher pencil and rubbing the color in with a finger. The shavings were then brushed off the paper with a soft brush.

8 Even in a study of a single plant or bloom, composition is important, and here it is beautifully balanced, with the main stem running diagonally from bottom to top, and the two flowerheads forming an opposing diagonal.

5 When the yellow gouache paint had dried, the stamens were outlined with pencil to separate and define them. To accentuate them further, a little dark green paint is dropped in at the bases.

6 The leaves were first painted in watercolor, after which layers of colored pencil, washed over with water, were added to build up depth of color and suggest shadows that help to bring the flowers forward.

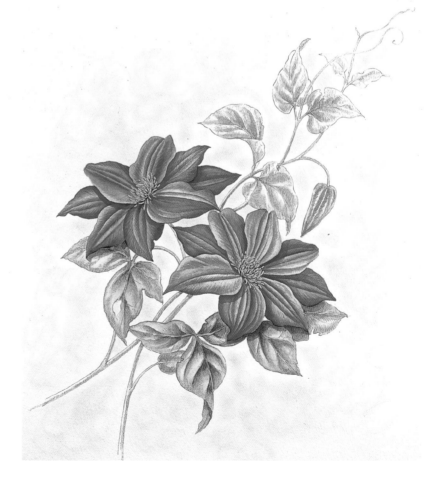

Further Practice

These five- or six-petalled flowers are one of the easiest to draw and paint, but their relative simplicity can be a trap. If you think something is easy you can become over-confident and make mistakes by not noticing obvious things, such as the effects of perspective. It is always wise to start with a basic circle or ellipse, according to whether or not the flower is turned away from you, then to mark the center and note the way the petals radiate out from it.

Potentilla: watercolor

1 Flood each petal with lemon yellow paint. As it dries move it to petal tips and flower center. Add stamens with cadmium yellow/brown pink, and sepals with lemon yellow/cobalt blue mix.

2 Use the same colors, with more cobalt, for bud and leaves.

Day lily: acrylic

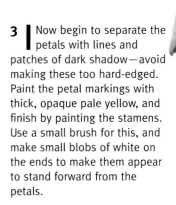

1 Acrylic can be used very much in the same way as watercolor, in a series of overlaid washes of transparent or semi-transparent color, but bear in mind that it dries fast, and once dry cannot be removed, so the lifting out technique sometimes used in watercolor work is not possible. Begin by laying an overall pale rose color, using a soft watercolor brush and paint well diluted with water.

2 Now build up the color by laying several washes over one another, finishing with a yellow wash to warm up the original pink and give it sparkle. Leave the delineation of the individual petals until you are satisfied with the overall color.

3 Now begin to separate the petals with lines and patches of dark shadow—avoid making these too hard-edged. Paint the petal markings with thick, opaque pale yellow, and finish by painting the stamens. Use a small brush for this, and make small blobs of white on the ends to make them appear to stand forward from the petals.

Black-eyed Susan: watercolor

1 | The main characteristic of this flower is freshness and simplicity, so if you work in watercolor, let your technique reflect this quality and don't labor the paint. Start by painting each petal separately but quickly, in varying tones of yellow.

2 | While the paint is still wet, drop a little stronger orangey yellow in around the edges of the petals where the forms curve away from the light. Make sure the paper is dry before painting in the dark flower centers, as you need crisp edges here.

3 | Paint fine lines radiating out from the centers, and finally paint the leaves, paying special attention to the shadow cast by the flowers. These help to complete the three-dimensional effect, with the darker tones making the flowers stand out in front of the leaves.

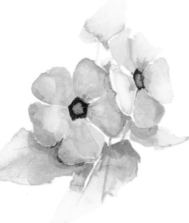

Geranium: oils

1 | Because these flowers are not intricate in shape and do not have a wealth of small detail to record, you can take a painterly approach to them, but you do want to be able to blend the colors well to show the soft gradations. You can do it with oil paints used at a fairly sloppy consistency. Start by laying on the darkest color, around the ed of the petals where they curve away from the light, and in the centers.

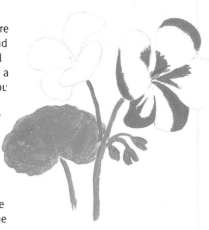

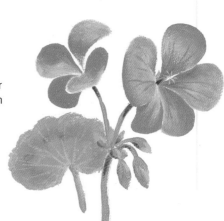

2 | Do not add more paint yet. Instead, before the color has begun to dry, take a clean brush and drag it down so that it spreads out more thinly in the center of each petal, allowing the white of the canvas to show through.

3 | Work the other flower in the same way, then add a band of light brown to the leaf, blending it in with a dry brush or your finger, and finally paint in the leaf and flower veins with a small brush.

Lipped and bearded flowers

If a flower looks complex, such as viola, iris, and some orchids, look for its symmetry and find the simple patterns. If only a single petal projects at the front, imagine this as the joining of a mirror image. For the Alstroemeria the artist has used acrylics loosely with a brush and painting knife to capture the minimum recognizable shape of the flower.

Color palette

white

cadmium yellow

crimson

emerald green

ultramarine blue

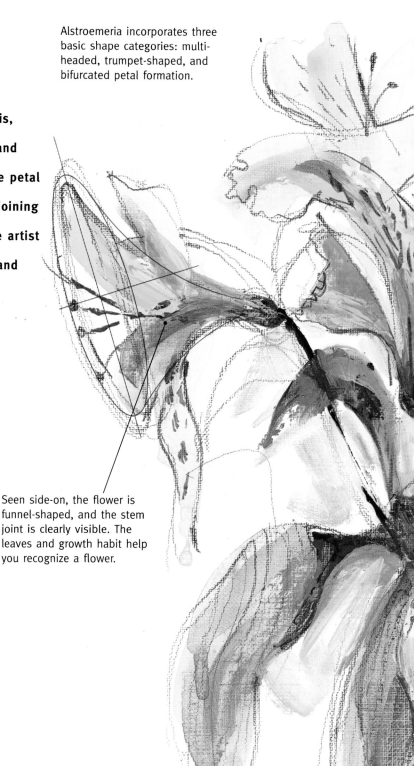

Alstroemeria incorporates three basic shape categories: multi-headed, trumpet-shaped, and bifurcated petal formation.

Seen side-on, the flower is funnel-shaped, and the stem joint is clearly visible. The leaves and growth habit help you recognize a flower.

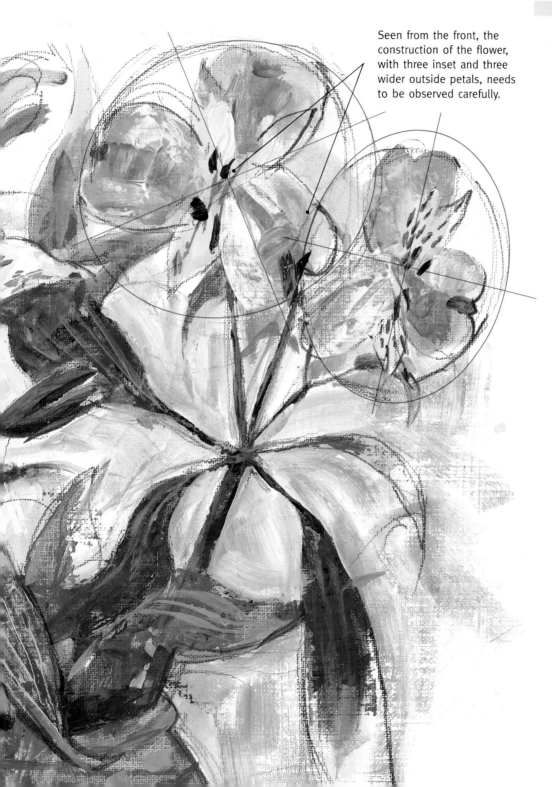

Seen from the front, the construction of the flower, with three inset and three wider outside petals, needs to be observed carefully.

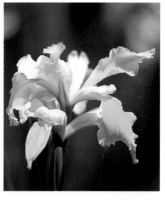

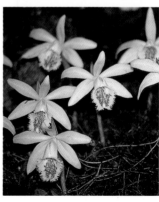

Top: Iris – showing complex shapes of petals. Middle: *Calceolaria* "Bikini" – rounded "pouched" flowers clustered together. Bottom: *Pleione* "Shantung" – complex orchids need simplifying into basic shapes.

Irises: watercolor

The two best-known methods of working in watercolor, wet-into-wet and wet-on-dry, are often regarded as separate techniques, but in fact most watercolor painters combine them in one painting, using wet-into-wet for certain areas and controlling the flow of paint so that it does not become unmanageable, as the artist has done in this painting. She has chosen hot-pressed paper rather than the more usual cold-pressed surface because the colors run into one another and form pools on the smoother surface, a tendency she likes to exploit.

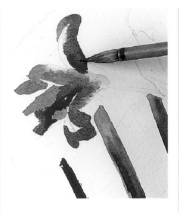

2 | She has begun the painting with the ivy leaf decoration on the chair, which she felt needed to be taken into consideration early on. She now paints Payne's gray around them, working wet-into-wet so that puddles of light and dark paint are formed. These describe the irregular highlights on the chair very well, and were not altered.

3 | The chair back also needed to be tackled early, as it would work in with the flowers, so the struts were painted before the first of the flowers. For the iris, ultramarine blue is merged wet-into-wet with purple alizarin, the main flower color.

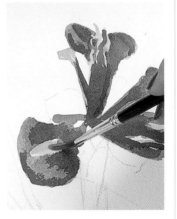

1 | The composition is quite an elaborate one, so the artist began with a rough pencil sketch before making her preliminary drawing onto the working surface. She uses a soft (4B) pencil for this.

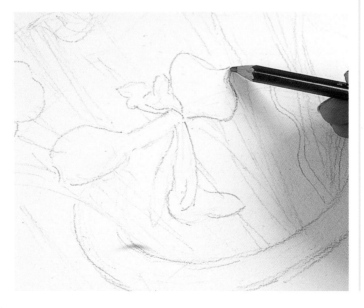

4 | The flowerheads were worked wet-into-wet, with successive colors dropped in with a well-loaded brush so that they ran together and formed pools and tonal gradations. The yellow areas had to be crisp and clear, however, so the paper was left to dry before adding these.

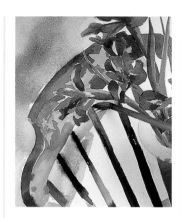

5 The chair back forms a background for the flowers, and was softened by keeping the paint very wet. A wet wash of the same gray as the chair is taken right over the chair struts and background, reducing the tonal contrasts.

6 When the flowers and leaves were dry, final touches were added wet-on-dry, with the darkest flower tones picked up with mauve straight from the tube and a No. 4 round brush.

7 The last stage was to paint the filmy green cloth. The main color was a mixture of lemon yellow and Winsor green, chosen to contrast with the purple of the irises.

8 The best way to give unity to a painting is to restrict the colors and repeat similar ones from one area to another, creating a series of color links. Here the gray background links with the chair, the shadows on the cloth pick up the leaf colors, and the blue of the vase reappears on the irises.

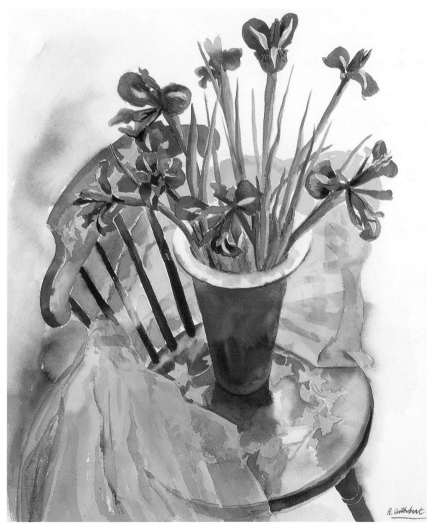

R. Cuthbert 97

Further practice

It is vital to sort out any confusion that arises where petals overlap each other at odd angles and protrude out of the flower. The perspective can be tricky to master, so rely on accurate observation of the shadows, and make sure you understand the structure of the flower.

Pansy: watercolor pencil

1 For the contrasting white lines, make indents by pressing hard with a sharp pencil on a sheet of paper placed over the artwork. Block in the flower using a purple pencil, leaving the center space clear; the white indents will then be revealed.

2 Intensify the color and shape by increasing the pressure on your pencil, and blend yellow into purple at the center. Use darker shades to enhance the shadows, and create light effects by scratching out color.

Orchid: acrylics

1 Apply a wash of raw umber to provide a muted background. Paint the basic flower structure onto this, using crimson and white for the petals, yellow and white for the center, and a mix of green for the leaves.

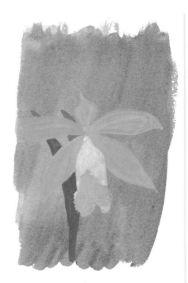

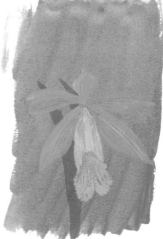

2 Scratch through the wet paint to reveal the background and give the petals a paper-thin appearance. Using sgraffito in this way also provides the structure with perspective, as it projects the cup outward.

3 To increase definition, paint on further layers and scratch through them with the end of the brush. Deepen the shadows with light glazes of blue and crimson before adding the final details.

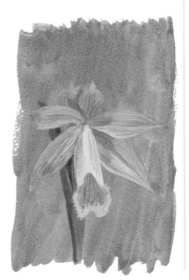

Snapdragon: watercolor

1 Outline the shape of the flower in pencil, then dampen the area of one petal and flood it with color. Here, alizarin crimson was used for the top, with cobalt blue below.

2 Continue painting wet-into-wet: add ultramarine for shadows, and cobalt blue, for light areas, and alizarin crimson, letting them blend and mix on the paper.

3 To make front petal project outward, apply pure bright red with cadmium yellow. To make other areas recede, leave them as a pale wash or lift out their colors.

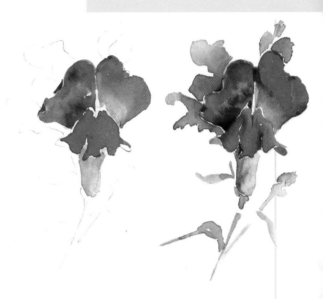

Sweet pea: watercolor

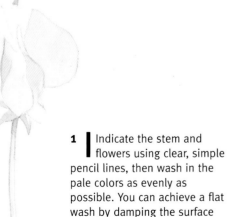

1 Indicate the stem and flowers using clear, simple pencil lines, then wash in the pale colors as evenly as possible. You can achieve a flat wash by damping the surface before applying the paint.

2 Deepen the shadows slightly, which will begin to create contours. Build up the strength of color with dry brushwork, and lighten areas by lifting out the paint with a clean damp brush.

3 Draw in the darkest shadow on the stem and the delicate veins of the petals with fine dry brushwork. Note the clear perspective of the differing planes of the petals.

Cup- and bowl-shaped flowers

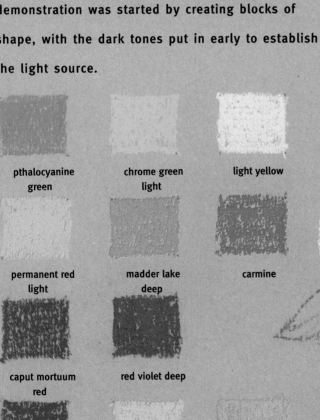

Where flowers have petals that form a gentle curve to the stem, the "cup" opens into a "bowl" shape. A simple single row of petals, as on a buttercup, still form a circle but bulge out and form ellipses to the calyx. This pastel demonstration was started by creating blocks of shape, with the dark tones put in early to establish the light source.

As the flower opens, it progresses from a cup to a bowl shape and flattens out. With the bowl lit up, the shadows would become less dense.

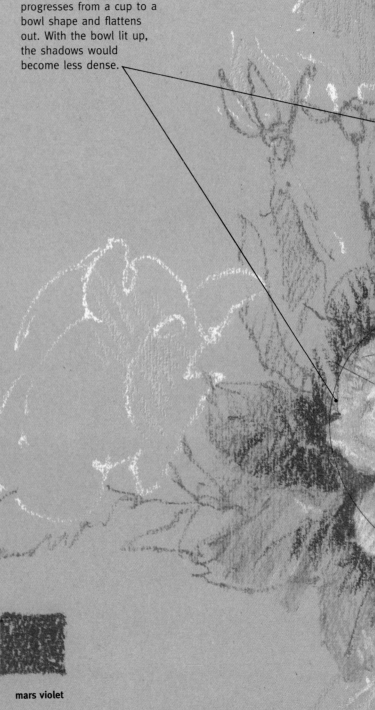

pthalocyanine green

chrome green light

light yellow

permanent red light

madder lake deep

carmine

caput mortuum red

red violet deep

ultramarine blue

orange

raw sienna

mars violet

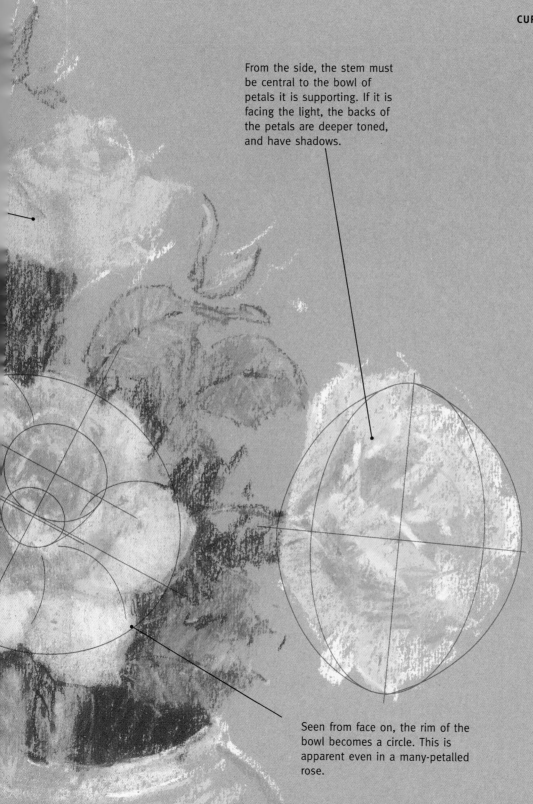

From the side, the stem must be central to the bowl of petals it is supporting. If it is facing the light, the backs of the petals are deeper toned, and have shadows.

Seen from face on, the rim of the bowl becomes a circle. This is apparent even in a many-petalled rose.

Top: *Clarkia lewisii* – showing a clean, clear bowl shape. Middle: *Ranunculus* – cupped flowers open to reveal complex center of bowl. Bottom: *Crocus sieberi* "Bowles White" – soft rounded contours opening to a cup.

Tulips: watercolor

Watercolor is one of the most popular of all the painting media, but it is not easy to correct if things go wrong, so to get the best results you need to plan the painting carefully in advance. This artist has given a lovely fresh quality to her work by using the technique called wet-into-wet, in which the paper is damped so that colors run into one another, but she has controlled the flow of paint carefully so that the edge of each shape is crisp and clear and there are no unwanted blobs and runs.

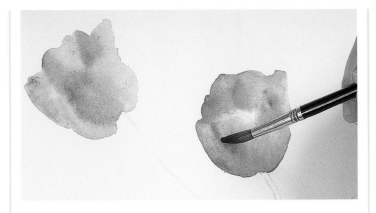

2 This stage shows the importance of preliminary drawing. Paint will not flow over from wet to dry paper, so the paper was damped only in the area of each flowerhead, within the boundaries of the drawn lines. Diluted permanent rose was then laid down, followed by darker magenta.

1 A loose drawing is made with a 4B pencil to place the main shapes. This is kept quite broad and unfussy, and mistakes are removed with a putty eraser. The artist is working on Smooth (hot-pressed) paper, which is often preferred for wet-into-wet methods, as it encourages the paint to flow.

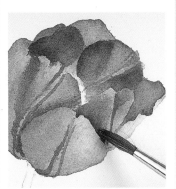

3 The secret of success with the wet-into-wet method is knowing exactly how wet the paper should be. It has been allowed to dry a little, but is still not fully dry, so that this darker color spreads out slightly to give a soft look to the flower.

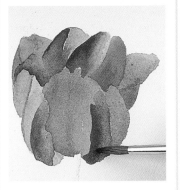

4 The paper is now almost fully dry in this area, and the artist is able to build up crisper definition, using a brush well-loaded with strong color. She is completing the top two flowers before beginning on the others because they were opening so fast that the shapes continually changed.

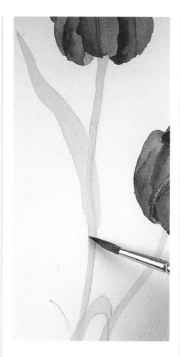

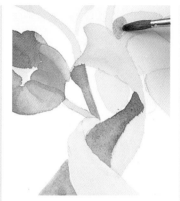

5 The first few strokes of the stem were painted with one sweep of a No. 7 brush, without lifting it from the paper, as this would have left a joining line. The leaves were painted in the same way, with green lake light and yellow ocher.

6 The pale green used for the main mass of the leaves was left until almost dry, and a rich, darker green—a mixture of olive green and Prussian blue—was added in distinct, positive shapes that emphasize the curl of the leaves.

7 The curving stem on the right and the leaves on the left have been reserved as highlight areas by painting darker greens around them. Notice how all the edges are slightly softened and blurred because the paper has not been allowed to dry fully.

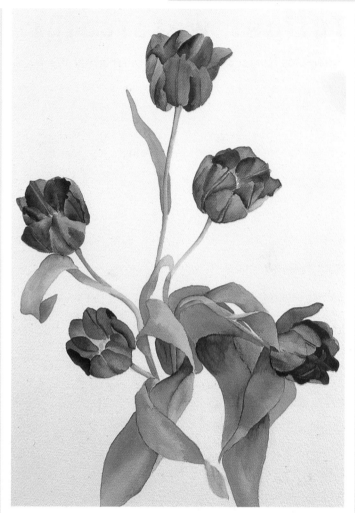

8 The strength of this delightful painting lies in the artist's experience of her chosen medium and her skill in handling it. The brushstrokes are clear and decisive, and nowhere has the paint been overworked or forced.

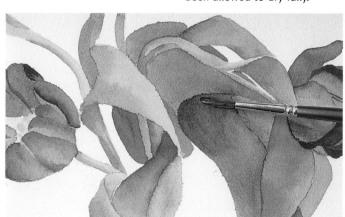

Further Practice

Whether your chosen subject is flowers, people, or landscape, experimentation is part of the painting process. Don't automatically stick to one medium and way of working; instead try out different possibilities, such as painting in oils or acrylics with a knife, working over an underpainting, or combining two or more media in one picture.

Rose: watercolor

1 Wash the sun-facing petals with lemon yellow. Leaving some areas clear, wash permanent rose/lemon yellow onto mid-tone petals. Tip the paper to let it flow into deep areas.

2 Add cobalt blue for darker petals. Use ultramarine and alizarin crimson with the mix for the darkest petals. Use ultramarine alizarin to mold petals and dry paint for petal lines and points. Add a touch of cobalt blue to the bowl of the flower. Sap green/cobalt blue for leaves.

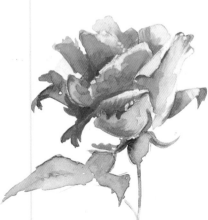

Solandra: gouache

1 Gouache can be used in a variety of ways. If you enjoy this medium, try working semi-transparent paint over an underpainting of colors that are complementary to those in the subject. You can adapt the method to acrylics if you prefer.

2 Mix up a green (the complementary of red) from lemon yellow and viridian and overpaint the leaves. Overpaint the flower with lemon yellow (the complementary of purple). Use just a little water and no white, so that the paint is semi-transparent, and the first colors will show through the second to create an intriguing effect.

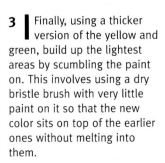

3 Finally, using a thicker version of the yellow and green, build up the lightest areas by scumbling the paint on. This involves using a dry bristle brush with very little paint on it so that the new color sits on top of the earlier ones without melting into them.

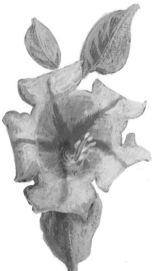

Blue poppy: watercolor and pastel

1 Watercolor is often used in combination with other media such as colored pencils or pastels. This lets you add details by drawing rather than painting them in with a tiny brush. Start with a watercolor wash of cerulean blue. This color is rather chalky, and won't go on smoothly, but this adds to the effect.

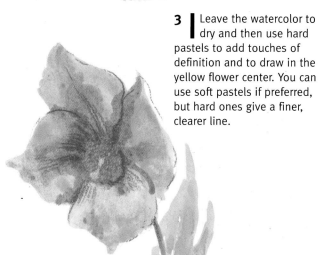

2 Work wet-into-wet for the next stage. Before the first wash has dried, drop some cobalt blue, used fairly strong, into the center and let it spread out.

3 Leave the watercolor to dry and then use hard pastels to add touches of definition and to draw in the yellow flower center. You can use soft pastels if preferred, but hard ones give a finer, clearer line.

Peony: acrylic with a knife

1 Acrylic can be used thinly, but can also be built up into solid impastos and applied with a painting knife. Knife painting must be done with great care, to preserve the shape and character of the flower. In the first stages, avoid using the paint too thickly.

2 Using a broad-bladed painting knife, or an ordinary palette knife, begin to apply thicker, lighter color. Use the knife to build up a series of edges describe the petals.

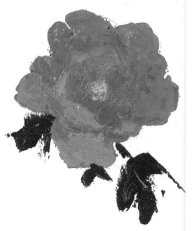

3 Continue in the same way, building up the paint surface. Try to make the knife follow the direction of the petals and leaves.

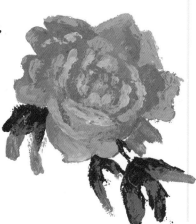

Leaves, stems, and seedpods

As the stem supports the flower, the leaves feed it and provide shades of green that enliven paintings and relieve any mass of color, and the seed pods hold further flowers. Although some of these details are subjects in themselves, they are not usually shown in isolation, except in botanical studies; they must, however, be pertinent to the flower.

Drawing and painting practice

If you are painting a flower arrangement in which the main role of the leaves is to provide a contrast of tone and color, you can generalize them to some extent, but you will still want to pick out one or two to treat in more detail in order to provide a fuller account of the type of plant you are depicting. In close-up studies of single plants, the leaves are, of course, just as important as the flowers. Whichever branch of flower painting you intend to pursue, practice drawing and painting leaves so that you can make your work more convincing.

Cranesbill: watercolor and watercolor pencil

1 With a pencil lightly draw the leaf and how it joins onto the stem, then use a wash of sap green to depict the tonal areas of the leaf. Shape the stem with pale burnt umber.

2 Apply yellow watercolor pencil over the leaf, and than wash it over with water to provide a warm glaze. Use darker green and brown in layers to intensify the details.

Eryngium: gouache

1 These leaves seem to demand a hard-edged treatment, which will make the most of the spiky, spiny, almost thorn-like qualities. Gouache is an excellent medium for this, as you can lay areas of flat color, overlaid with unblended darker colors. If you do not have a range of gouache paints, watercolors can be mixed with gouache white to make them opaque. Begin with a careful drawing, and then lay flat color over the fronts of the leaves, leaving the back edges as white paper.

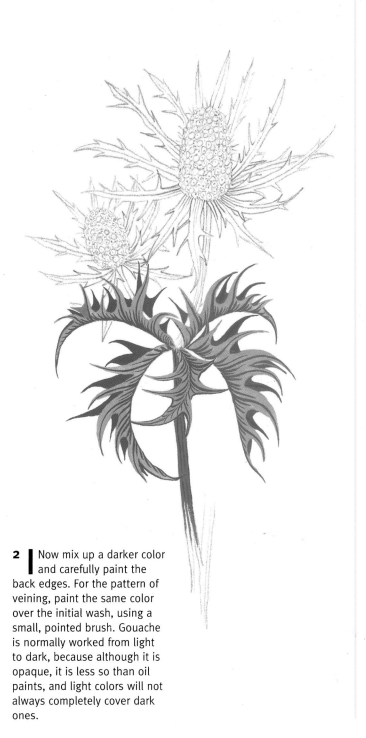

2 Now mix up a darker color and carefully paint the back edges. For the pattern of veining, paint the same color over the initial wash, using a small, pointed brush. Gouache is normally worked from light to dark, because although it is opaque, it is less so than oil paints, and light colors will not always completely cover dark ones.

Camellia leaf: acrylic

1 A great many different techniques are possible with acrylic, which makes it an exciting medium to experiment with. Here the sgraffito method has been combined with overlaid colors. Remember that you cannot wash out acrylic when it has dried, and mistakes can only be corrected by overpainting, so it is wise to begin with a pencil drawing. Paint the brown stem first, and then lay a yellow base color for the leaves. It does not matter if the brown shows through the yellow, as you will be laying further color on the leaf.

2 Now you must work fast, because the paint must remain wet. Use it at a fairly sloppy consistency, mixed with acrylic medium plus a little water. Lay on a dark green made from a mixture of viridian and crimson, then use a brush handle to scratch this top layer away for the veins. For the highlights, apply opaque white used relatively thinly, and soften where necessary with a brush dipped in water.

Rose leaf: pastel

1 Pastel, although a soft, crumbly medium very prone to smudging, can achieve very fine, precise effects if it is controlled carefully and the colors are well blended. Do not, however, try to use it for very small-scale work; a drawing measuring about 6 inches is about the minimum to give you scope for blending and adding detail. First block in the leaf shape, using a light and a dark green, and letting the strokes follow the direction of the leaf.

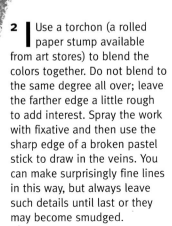

2 Use a torchon (a rolled paper stump available from art stores) to blend the colors together. Do not blend to the same degree all over; leave the farther edge a little rough to add interest. Spray the work with fixative and then use the sharp edge of a broken pastel stick to draw in the veins. You can make surprisingly fine lines in this way, but always leave such details until last or they may become smudged.

Passiflora (passion flower) leaf: oil pastel

1 These leaves have a delightfully elegant shape, and the two-toned effect of the yellow veins against the deeper green make them an interesting prospect for color work. Try oil pastel, keeping the sticks well sharpened so that you can make the edges crisp. Start with the yellow, then pick out the veins in olive green.

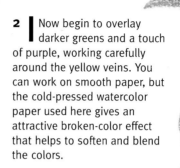

2 Now begin to overlay darker greens and a touch of purple, working carefully around the yellow veins. You can work on smooth paper, but the cold-pressed watercolor paper used here gives an attractive broken-color effect that helps to soften and blend the colors.

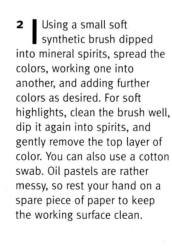

Toothed viburnum: oil pastel

1 Another way of using oil pastel is to spread and blend the colors with mineral spirits. Oil pastels cannot be blended with a finger, as soft pastels can, as they have a quite different consistency. But the spirit has the effect of melting the pastel, making it more like paint, and thus facilitating blending. This method works best on smooth paper. Begin by using the pastel dry, filling in the shape with two or three different greens. Sharpen the sticks, or use the edge of a broken stick, to make clear edges.

2 Using a small soft synthetic brush dipped into mineral spirits, spread the colors, working one into another, and adding further colors as desired. For soft highlights, clean the brush well, dip it again into spirits, and gently remove the top layer of color. You can also use a cotton swab. Oil pastels are rather messy, so rest your hand on a spare piece of paper to keep the working surface clean.

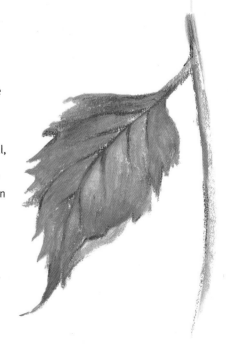

Ivy leaf: acrylic

1 Painting on smooth board or paper with thinned acrylic and sable or soft synthetic brushes gives you excellent control. You can include as much detail as you wish, and build up dark tones and rich colors through a series of glazes, as in watercolor. Begin with a wash of thin color over the whole leaf, avoiding making it too flat and even.

2 Lay further layers of thinned color, and for the final layer, use separate brushmarks that do not fully cover the color beneath; this gives a realistic slightly mottled impression. Finally, use a pale yellowy brown and a very small brush to draw in the veins. Because acrylic is opaque, you can work light over dark, whereas with watercolor the veins would have to be reserved as highlights, a fiddly and difficult process.

Tree peony: watercolor

1 Draw the outline in pencil, and then use a pale shadow mix of ultramarine blue and new gamboge to mark the contours. Define the veins and stalk with alizarin crimson.

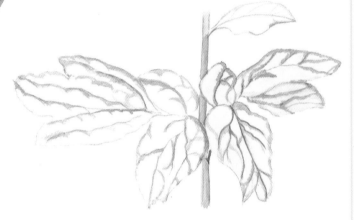

2 Gradually deepen and intensify the colors, and use small washes to model the leaf. Add the details and pick out the shadows and veins with a fine brush.

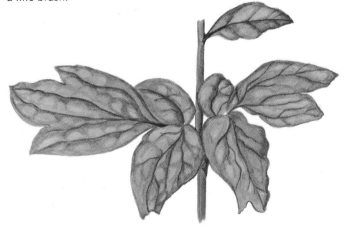

Pelargonium leaf: watercolor

1 If you intend to play the leaves down slightly while still showing their main shapes and colors, but giving more emphasis to the flowers, wet-into-wet watercolor is a good method. Begin by wetting the paper in the exact shape of the leaf (you can make a pencil drawing first if you like) then flood on the color. The paint will not spread beyond the outline, because the dry paper will stop it.

2 With the paper still wet, drop in a reddish brown to make a circle around the yellow, then use a darker olive green around the edges in the same way. The colors will run together slightly so that there is no hard division between them.

3 To define the twigs, you can either let the paint dry and draw pencil lines, or make impressed lines with a paintbrush handle while the paint is still wet. This creates very much the same effect, as the paint collects in the indented lines.

Day lily leaf: watercolor

1 The striking characteristics of these lily leaves are their elongated shape, curving over at the end, and their dark markings. For a detailed close-up study, a carefully controlled watercolor technique is a good choice for making the most of these qualities. Begin with an all-over wash of yellow-green.

2 Let the first wash dry completely, and then begin to build up the depth of color with a series of glazes (overlaid washes), leaving each one to dry before adding the next. Finally, use dark green paint to "draw" the veins and markings with a small, pointed brush.

Drawing and painting practice

The stem of a flower is very much part of its overall character and structure. Even if you do not wish to engage with this part of a plant in detail, you need to be aware of the relationships between stem and flower. Some stems are thin and fragile, only just supporting the weight of the flowerhead so that it bends over; others are firm, straight and stiff, holding the flower firmly upright. Practice drawing and painting stems on their own, making a note of their individual differences.

Ribbed stem: pastel

1 This type of ribbed stem is typical of several plant species. To give an accurate impression, you need to be able to make clear, fairly straight lines running from top to bottom, so a drawing medium such as colored pencil or hard pastel (used here) would be a better choice than oil paint; it is hard to make fine lines with thick paint and a brush. Lay down an olive green base color with hard pastels.

2 Rub the base color well into the grain of the paper and then spray with fixative to prevent smudging. To make the fine lines and sharp edges, use a spare piece of paper as a mask. Hold the edge down on the work and run the pastel stick along it.

Yellow roundwort: watercolor

1 This plant, of the nettle family, has a square-sectioned stem composed of a number of flattish planes producing sharper tonal gradations than you would see on a round section. Blending methods such as wet-into-wet watercolor would thus not be appropriate; if you use watercolor, work wet-on-dry, starting with a flat overall wash.

2 Leave the first wash to dry, then take a darker color right down one side. To emphasize the division between the two planes, either make a pencil line, or with the paint still wet, draw into it with a paintbrush handle. Suggest the small hairs in the same way.

Forget-me-not: gouache

1 If you were painting a group of these charming flowers in a garden setting you would not need to engage in detail with the stems, indeed you would probably not even see them. For a close-up study, however, you would want to show their characteristic slight ribbing and the sparse hairs. Working on Smooth paper with thinned gouache (or watercolor if you prefer), paint the stem as a flat color.

2 Let the first wash dry and then paint darker lines right down the stem for the ribbing. You will need a very small brush (No. 1) for the hairs, and take care not to overload it with paint, as this could make blobs. For a larger plant, such as the poppy shown (*center, far right*) the hairs could be drawn in with pencil or colored pencil, but in this case painting them with the small brush is preferable, as it gives much finer lines.

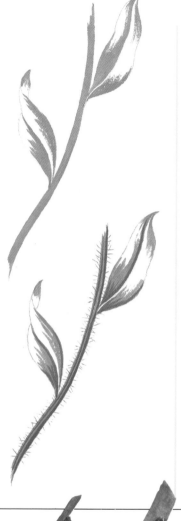

Poppy: mixed media

1 Poppies are tall flowers, but their stems are relatively thin, and curve under the weight of the flowers, buds, or seedpods. This is an attractive quality, as is the hairiness of the stems. Pencil, watercolor, and water-soluble colored pencil can be used in combination, starting with a watercolor wash and adding detail in colored pencil while still wet.

2 Leave the first colors to dry and then add the hairs with water-soluble pencil used dry. Make sure you sharpen it very thoroughly, and draw each hair with a little flick, using the minimum of pressure. Notice that the hairs do not always follow the same direction, but crisscross one another in places.

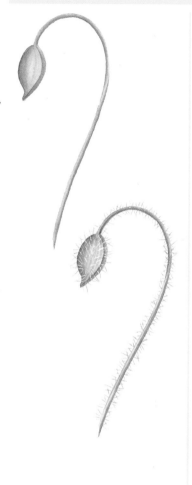

Rose stem: acrylic

1 The lovely soft blooms of the rose contrast with its characteristic tough, thorn-clad stems, which make an intriguing study on their own. To convey the bark-like texture, acrylic can be used in a dry-brush technique. You could do the same with gouache. Start with a yellow brown mixture for the stems and a darker brown for the thorns.

2 Now mix up some fairly stiff paint and use a bristle brush. Dip just the very end of the brush into the paint so that it holds only the minimum, and lightly scumble both darker and lighter colors over the first.

Drawing and painting practice

Seedpods can be one element in a painting, adding variety to the shapes of flowerheads and leaves, or they can be a subject in their own right. The shapes can be fascinating, and the colors sometimes more vivid than those of the flowers that precede them. Making studies of seedheads will also help you gain an understanding of the life cycle of the plant in question.

Rosehips: acrylic

1 The seedpods of the rose family are wonderfully rich in color, and could make a panting subject all on their own, or perhaps contrasted with white flowers. One of the best ways of building up strong color is by glazing, and acrylic is particularly well suited to this method. Start by painting the shapes flatly, using the red at full strength but not too thick.

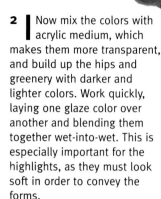

2 Now mix the colors with acrylic medium, which makes them more transparent, and build up the hips and greenery with darker and lighter colors. Work quickly, laying one glaze color over another and blending them together wet-into-wet. This is especially important for the highlights, as they must look soft in order to convey the forms.

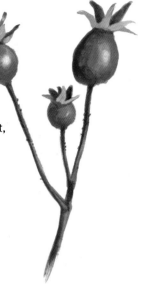

Poppy seedhead: pastel

1 The seedheads of poppies are unexciting in terms of color, but their shapes are wonderfully dramatic, which is why they are popular as components of dried-flower arrangements. For those you can afford to use a bold medium such as pastel, as there are no small details to contend with. Begin by establishing the main shape, and block it in with dark green.

2 Now lay on lighter colors—olive greens and yellow ocher, and blend them together with your finger or a cotton swab, making curves that follow the direction of the ridges from top to bottom. At the top, the tonal gradations are sharper, so avoid blending here; instead lay dark green and pale yellow ocher side by side.

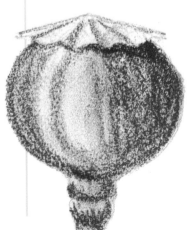

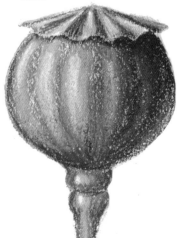

Sweet pea: oil pastel

1 For this pod, similar to that of the edible pea but hairier, you could choose a medium and technique that help you convey texture. Oil pastel, used here, can be scratched in to reveal colors beneath. Begin with a yellow base color, working it well into the paper, then lay blue more lightly on top.

2 Now "draw" the hairs by using a fine knife blade to scratch into the blue, making a series of yellow lines. Take care not to scratch so hard that you also remove the yellow. This technique is called sgraffito, and you can build up effects with many layers of color, each time scratching into the one below.

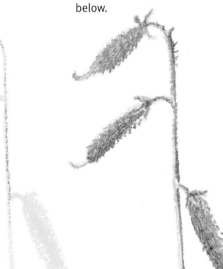

Honesty: watercolor

1 These large seeds are protected by flat, round pods, initially green but becoming silvery and tissue-like when dried. The crinkly texture can be suggested by using a method called wax resist in combination with watercolor. Start with the stem, carefully damping the area and letting the colors flow gently into one another. Then paint in the seeds and outlines of the pods.

2 Scribble lightly over the seedpods with a household candle, then lay a wash of ocher watercolor on top. The paint will slide off the waxed areas to give an attractive mottled texture hard to achieve by any other method.

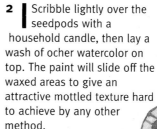
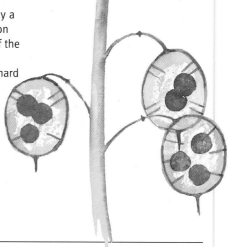

Passiflora: watercolor

1 You will need to be able to build up the forms of these gently rounded, fruit-shaped pods, to make a contrast with the flatter, more angular shapes of the leaves. The wet-into-wet and lifting out watercolor techniques are ideal. Start with a light pencil drawing, then damp the paper within the lines with a brush and clean water, and float on a yellowy green.

3 Make the soft highlights on the pods by dabbing into the paint with a small sponge or piece of absorbent cotton to remove some of the color. This is called lifting out. Finally, with the paint for the leaf still wet, draw in the veins, using the end of a paintbrush. This makes linear indentations that the paint flows into to create dark lines.

2 While the first application of paint is still wet, drop in small amounts of darker green and brown on the leaf beneath the lower seedpod, and then work on the stem in the same way.

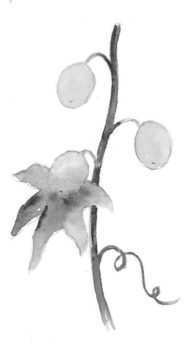
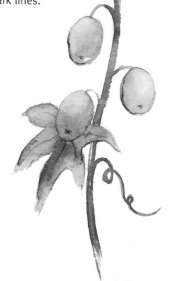

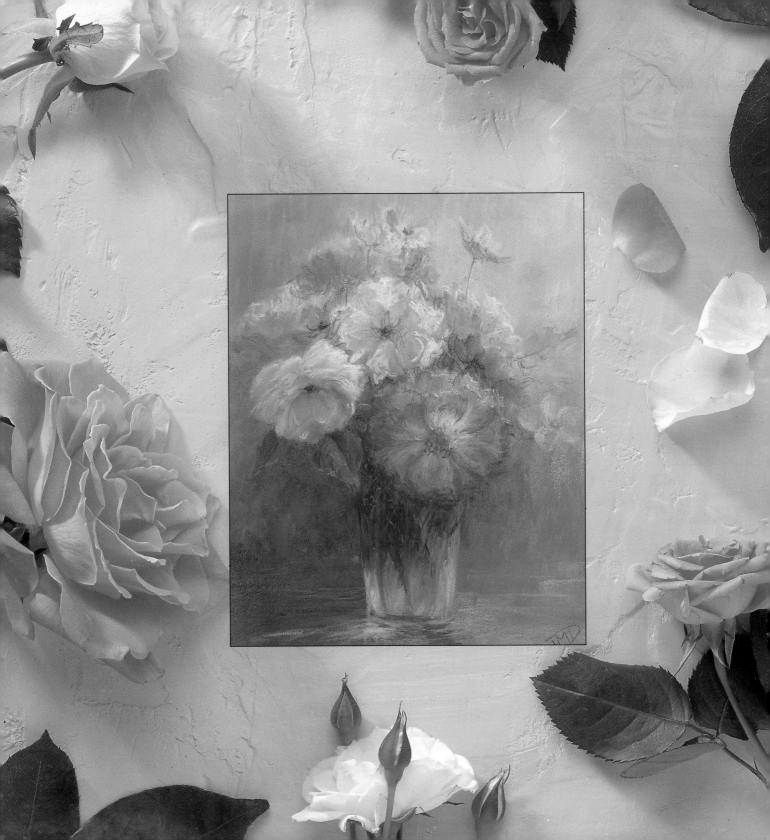

FLOWERS IN CONTEXT

Whether you choose to paint flowers in a vase or still on the plant, study the work of experienced artists to help you sort out your priorities.

Organizing your subject

If you are new to flower painting do not begin with an over-ambitious project—start with something easily available and simple in form.

A pot plant could be ideal, preferably one you have tended for some time, as you will be familiar with it. Or you could make a simple grouping of flowers you have watched through their growing stages from leaf to bud, and flower. To make sure you understand the structures, start with leaf studies—this will also give you practice in mixing greens. Then tackle a single flower, making drawings in different stages, and finally move on to the whole, including the vase.

COMPOSITION Give thought also to how you will compose the subject. Have the end result in mind and then work out how you are going to achieve it. The size and proportion of the paper or canvas will start the process, so choose a format that suits the subject. A single camellia bloom could fit well into a square, oval, or circle, but a group of tall delphiniums or gladioli could look ridiculous. Look at the most important object, usually the largest bloom, and then decide what leaves, stems, and other objects are going to fit around it. Note whether the plant grows horizontally or upright. This will determine whether you use a "landscape" (horizontal) format or a "portrait" (upright) shape.

You might want to include other objects in the painting. Imagine the interior of a greenhouse, where the pots are as important as the flowers, creating lines that can give distinct form to the composition. Move objects around, overlap, and interlock them so they give dimension as well as a variety of shapes.

If you are painting flowers in a vase the container is part of the composition, but it should not take up more than one third of the overall height, or it will become the focal point. There are some stylish paintings of tall vases with flowers sticking out the top, but these fall more within the category of still life.

Avoid dividing the painting equally; if it is half flowers and half container you are creating a "horizon" across the middle. Experiment with different eye levels which have an important bearing on the composition.

Portrait or landscape?
Space is an extremely important compositional element. Use a rectangular viewfinder to work out what you want to show and whether it will fit, then make a rough sketch. Wide-spreading plants need room sideways, and tall flowers must not be cramped.

Including other objects
Color, textures, and hard shapes can all complement the main subject. If these are not thought out, they can just become clutter.

(Above) Shapes and props should support the subject; they must not distract, or corrupt the colors.

(Right) Any objects added will change the emphasis. Do not lead the eye away from the focal point.

Horizon lines
Use diminishing horizontal lines to create space. An unbroken line across the middle breaks the attention into two halves. Off-set the subject slightly rather than place it dead center.

Eye levels
Use eye levels, perspective, and vanishing points to help describe the plant's character, its height, and the way it grows. Too much dreary space around the subject diminishes its importance.

OVERALL SHAPE Triangles are a classic compositional device, and curves naturally play a large part in flower painting. Avoid too much symmetry, and try to draw the eye into and around the picture. Do not place a large round bloom dead center like a target, instead offset it and support it with a couple of other solid shapes. Lines that cut the picture in verticals and horizontals can stop the flow or even lead the eye out of the picture. Either break them up with other shapes or keep them off center and angled to give good perspective. If there is a table or window that you want to include, angle the lines in toward the central theme, making them frame and support it.

BACKGROUNDS Do not ignore the background, because it gives depth and solidity to the flowers. Many experienced artists start by putting the background in first. One of the ways of keeping the painting from becoming flat is to pay regard to the foliage at the back. Flowers in sprays will have this kind of "back interest." The shadow patterns of leaves on a wall behind can make a wonderful background, and are another way of giving depth to the painting.

Backgrounds
Change the background, and you can change the painting. A beautiful, detailed study may be appropriate, even stunning, on pristine blank white paper, but once you start to add anything, even a tiny amount of color to the background, it begins to affect the subject.

Backgrounds change color emphasis, lend atmosphere, and give life to the subject.

If the background is strong, make sure it adds to the whole, rather than takes over.

Compositional Extras

A fallen petal, a pebble, a ladybird, or a butterfly can do wonders for the composition and add points of interest to the painting. A drop of water on a leaf or petal adds a highlight. Don't overdo it though and do keep the sense of reality. Putting in a large snail that is completely out of scale with the flowers could give a disturbing effect.

Most butterflies close their wings when they settle. Very few sit there with them conveniently spread out—although moths are more obliging. Try not to make them look as though they have been pinned to a board for the last ten years, and again, keep them in scale.

Daffodils

The artist tried several ways of setting up the subject for this painting, giving thought to what she wanted to express about the daffodils. The primary considerations were color and the strong upward thrust of the spring flowers, and a blue background was a natural choice helping to emphasize the bright yellow. Including a lot of white to keep the color scheme fresh also seemed natural, and as she was working in pastel, the artist knew she could introduce a rhythm with the strokes, making both the background and foreground play a part in the composition.

Alternative set-ups

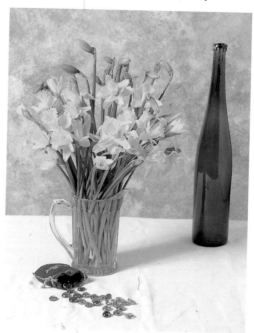

Although the tall, dark bottle works well in terms of color and could give height to break up the line of the table, it is distracting, and the glass pebbles at the front are too fiddly, although the curved line does lead the eye in. The flowers seem diminished rather than emphasized.

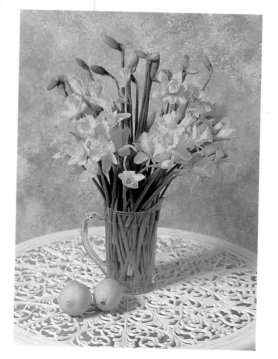

The round shape of the tabletop provides a good balance for the flowers and straight-sided vessel, and the pattern echoes that made by the flowers. Something of the same color was needed to link the areas of the composition, and the lemons worked well, keeping up the overall theme of freshness.

Developing the composition

A simple pencil sketch to work out curves, lines, composition, and placing on the paper is good preparation for a complicated subject. It concentrates the mind and helps you sort out what is most important.

Pastels allow you to make simple colored sketches very quickly. Here the artist experiments with a landscape format, using just broad masses of color divided into areas.

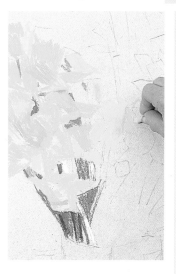

1 After making a very faint outline in pastel pencil, the artist starts on the flowers, working from left to right so that the colors do not smudge under her hand. She uses short, directional strokes, creating different planes within the shapes.

MATERIALS

Neutral gray Mi-Teintes paper, used on the smoother side

COLORS

Light chrome yellow, dark chrome yellow, mid-green, light green, blue hues and green hues
White, magenta, pale gray hues

2 Note how much dark blue has been used when placing the stems. This will be adjusted later, but it was important to establish the strong tone and color contrasts from the outset. The flowers are built up more firmly with soft pastel.

The landscape format is rejected, and a more natural portrait shape tried out. The important lines are confirmed, such as the circle of the table, the rim of the jug, and the shapes of the lemons.

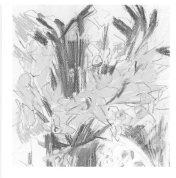

In this second color study, the artist looks for tonal contrasts, and explores the idea of using buds as shape and tone variations to break up the yellows. It is worth comparing this with the final version of the painting to see how her ideas were developed further. The buds began to open during work, but she had this preliminary study to refer to.

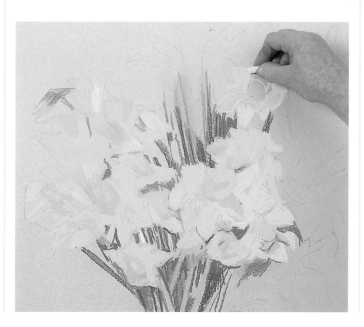

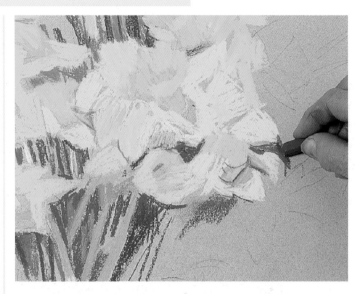

5 Hard pastel is used for this area of the jug, which needs firm definition. The first stage was to make a bold line for the rim that defines the ellipse. Note that on the right of the picture, yellow has been laid over the original deep blue to produce a rich green.

6 Before either the background or the table are filled in, the lemons are placed, with deep orange shadows running along the contours of the fruit. The yellow is echoed by some softly smudged color at the bottom of the jug.

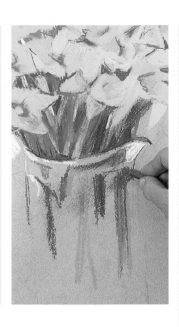

3 Now the deep blue used for the stems is taken around the edges of the petals to create strong shadows between the flowers. In a later stage, yellow will be laid on top to create a deep green (see step 5).

4 A finger is used to smudge and blend deep blue into yellow. The flowers will continually be adjusted for contrasts as the surrounding colors go in. The artist has already begun to build up the background, starting with strong directional strokes of pale gray.

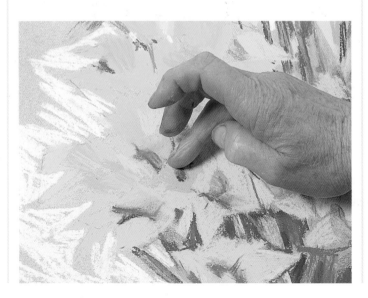

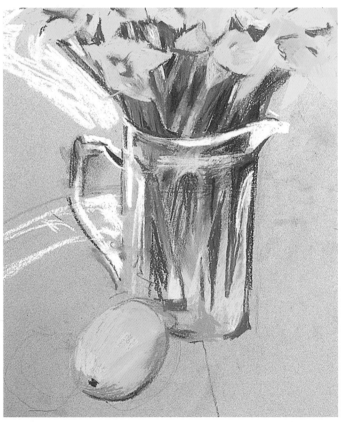

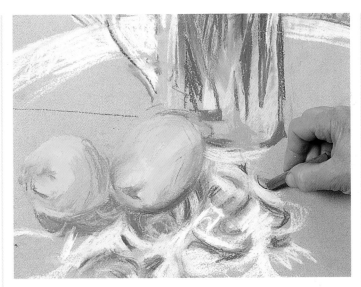

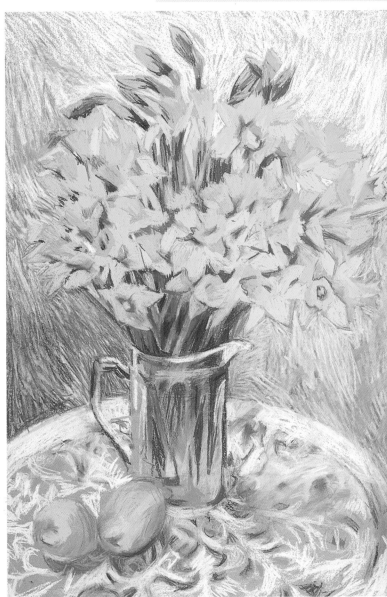

7 | Magenta-purple is to be introduced into the background, as this is the complementary of yellow, and helps emphasize the flowers. Here the same color is used for the open pattern of the tabletop. Again hard pastel is chosen, in order to make crisp lines.

8 | Directional strokes of soft pastel are used for the background, with several colors laid side by side and left unblended to create a swirling pattern.

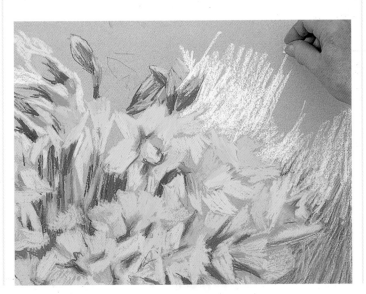

9 | The finished work is full of life and movement, stemming from the way the pastel strokes have been used. Look back at the photograph of the set-up and you can see how exciting the painting is, especially the background.

Outdoor flower painting

Painting flowers out-of-doors presents you with a wide range of choices and thus many decisions that have to be made.

Any painting, of course, involves decision-making: when you are dealing with an indoor set-up or a close-up study, for example, you will have to consider color and composition, but when you take your paints out into the wider world you will be faced with the more difficult decision of what to focus on. Confronted with a field of sunflowers or poppies, or massed flowers in a garden bed, will you single out one plant for close attention, or treat the flowers as landscape features, dealing with them in more general terms?

DIFFERENT APPROACHES Your choices will depend partly on your own interests and partly on the flowers. Many wild flowers such as bluebells and primroses grow in masses, and this is part of their charm. Others, for example the foxglove, or the dramatic tall plants of the *Umbelliferae* family, could make a lovely study on their own, set against their natural background. In a small patio garden, flowers and plants in tubs could be treated in much the same way as an indoor flower arrangement, with the bonus of allowing you to exploit the effects of sunlight and shadow. In a large garden, perhaps that of a public park, the overall color scheme of an individual bed could provide inspiration for your painting, and you could treat the flowers in a more generalized way. If you observe the shapes, colors, and growth habits carefully, you will find that you can suggest a particular flower quite accurately with a few well-placed brushstrokes or pastel marks without going into detail.

COMPOSITION If you decide on a broad view, you must think about the composition and focal point, and consider what you might leave out or play down. A viewfinder is a great help in the planning stages of a painting, so ensure that this is part of your equipment. You can make one by cutting a rectangular aperture in a piece of card. Do not be afraid to rearrange nature in the interests of your painting. Artistic license is more than just a figure of speech, and you can move a bush from one place to another or leave it out altogether if you wish. You can also

Composition out of doors

Decide what to leave out and the composition will begin to take shape. A viewfinder is a great aid, though making a square of your first finger and thumb is almost as good. A homemade viewfinder is made of two "L"-shaped pieces of card joined together with paper clips.

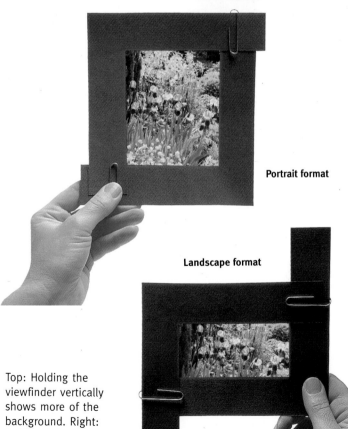

Portrait format

Landscape format

Top: Holding the viewfinder vertically shows more of the background. Right: Holding it horizontally crops out the background.

exaggerate some feature in your subject, perhaps giving more emphasis to the shapes and colors of shadows in the foreground or on pathways. If you make shadows part of the composition, paint them first, or at least make a note of their direction, as they will change dramatically as the day progresses.

If you choose to focus closely on one or two plants, avoid letting the background become too dominant or it will detract from the focal point. Often you can treat background flowers, foliage, or trees as nebulous shapes or simply areas of color. This will also help you create the sense of space that an outdoor subject demands.

Equipment for painting outdoors

Travel light, pencils or pastels are best, other mediums need auxiliaries which can be heavy and spill. You may also have to carry wet artwork home.
1 Camera for recording information.
2 Paper towels.
3 Selection of brushes in protective tube.
4 Plastic water container.
5 Pencils for sketching, making color notes.
6 Hard-backed sketch pad or watercolor blocks.
7 Paints – basic colors.
8 Plastic bag for sitting on and/or carrying equipment.
9 Two "L"-shaped viewfinder cards.

Above: Tubs and pots can be moved around to give strong compositional shape and take advantage of lines.

Right: Move around the plants and select the view. Photos record every object so you will still need to make choices.

Summer garden

Outdoor flower painting overlaps into landscape, and is subject to the same problems; inevitably the sun will move around and clouds come and go, creating or destroying shadows, so you will need to record effects of light and shade early. One way to tackle outdoor subjects is to work indoors from a combination of photographs and sketches, as the artist has done here. You need not be an expert photographer, in fact it may be better if you are not, as you should view photographs as an aide-memoire for certain aspects of a scene rather than trying to faithfully reproduce the whole. Sketching will isolate important features and help you work out compositional ideas. Reference material gained in this way is useful in changeable weather conditions, or for plants growing in inhospitable places, such as half-way up a cliff.

Working from photographs and sketches

The artist has drawn on her memory of a familiar scene, together with her experience gained sketching flowers in their habitat. The photographs served the purpose of providing detail, particularly of the poppies, and of suggesting an overall color scheme, but they play no part in the composition, which was planned independently.

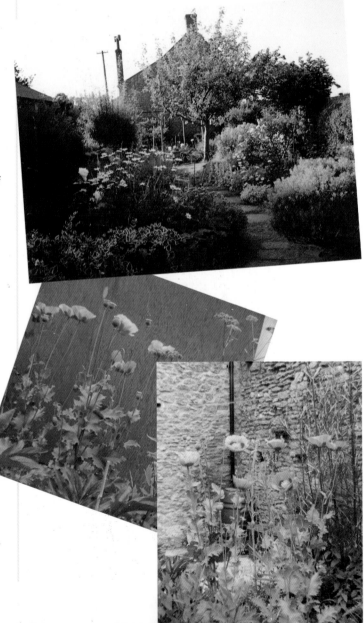

MATERIALS

Acrylic paints (tubes)

Masonite primed with acrylic gesso primer

Long-handled, synthetic and bristle brushes, plus small long haired sable for fine lines

COLORS

Raw sienna
Payne's gray
Alizarin crimson
Cadmium yellow
Burnt umber
Phthalo blue
Cadmium red medium
Mars black
Titanium white

The compositional sketch was made on the spot, very rapidly in pencil. The roofline and the gate give the distance, the urn marks the middle ground, and the flagstones take us in from the foreground. These are all noted as salient points, with the plant shapes merely indicated.

1 The artist likes to build up thin layers of color, working on a smooth surface. The masonite was primed and then a thin wash of burnt umber was applied over all. With the paint still wet, the end of the brush was used to scratch in the positioning of the important lines as established in the primary sketch.

2 The artist began by lightly blocking in the sky, the house, and the tree mass. She now places the poppies, equally lightly. Note how the ground color shows through the pale colors to "take down" the tonality overall; the color scheme she has planned is quite subdued.

3 On this very smooth surface, the marks of the brush show, and will play a part in the finished effect. A bristle brush is used at this stage, as the marks made by a smooth synthetic would be less obvious.

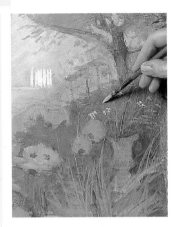

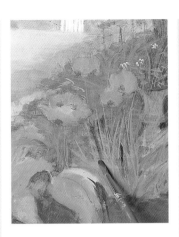

4 The background is now largely complete, with the successive veils of thin paint giving a misty atmosphere of early-morning sun. The artist turns her attention to the foreground, now using a softer synthetic brush for shadows beneath and around the leaves.

5 The tiny white flowerheads were applied with the tip of a bristle brush, and now a pen dipped into liquid green paint is used to draw the stems. The urn has been left as a negative shape against the darker background.

6 Very fine brush drawing is possible on a smooth surface such as masonite, Here a soft brush loaded with cadmium red is used to outline the paving stones. The painting is balanced out with light washes that allow layers beneath to show through.

7 The poppies have been given a little more definition, and further layers of thin color are applied to the stems beneath. Notice that the urn still remains the original ground color, yet seems to stand out in relief.

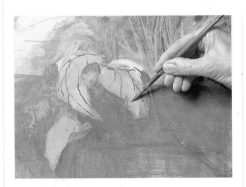

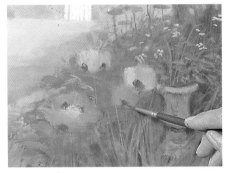

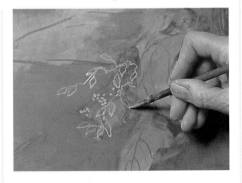

8 Paint mixed to a creamy consistency is dribbled on from the tip of a pointed brush to "draw" veins on the leaves. This linear detail sharpens up the focus and contrasts with the washes in the immediate foreground and background.

9 The colors of the flowers are strengthened and form is built up. Because the ground color is dark and the overlays of paint consistently thin, all the colors are muted, enhancing the misty, early-morning feel of the painting.

10 More fine brush drawing brings the lacy leaf detail into sharp focus against the dark washes on the flagstones. This close-up photograph shows the importance of the brushstrokes, which enliven the flat area of foreground.

11 The urn has now been given shape and solidity with lighter brushstrokes following the curves of the ellipses, and thinner lines of light and dark are applied to lift the plants into relief.

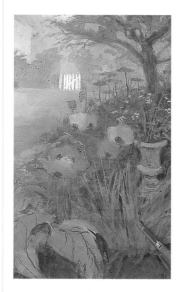

12 The painting is somber in color but full of interest, partly due to the sensitive paint handling and layering of color. The painting has been cleverly composed so that our eye is led from one area to another, notably from the foreground poppies to the white flowers and thence to the white gate, an important focus point.

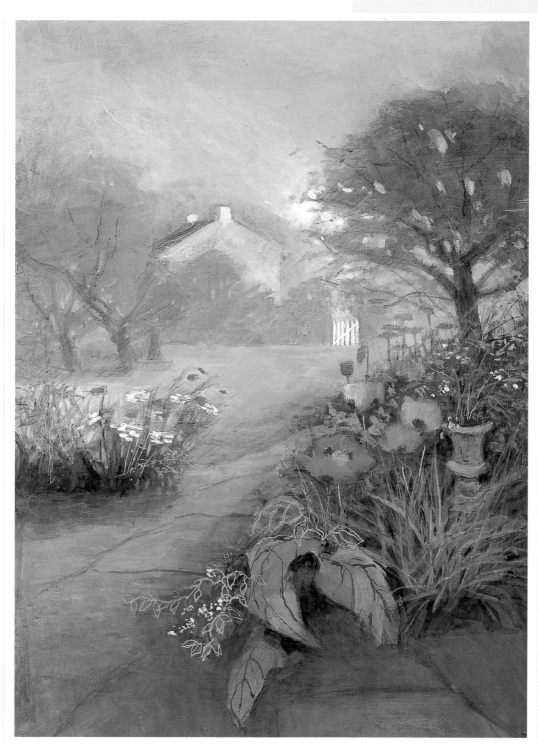

Editing out detail

The degree of detail you include in your painting is a very personal decision. You may not wish to paint every stem or serration of a leaf, but how do you decide what is most important?

Like most painting decisions, this will come with experience. If you work standing up at an easel and thus keeping a distance from your work the choices will sort themselves out to some extent, because you will be able to see the broad effect, and the choice of medium also has a bearing on the question of detail. Thick paint or soft, crumbly pastels, for example, both place natural restrictions on the amount you can include. A heavily textured paper or canvas will also act as a filter for detail, but you will have to accept that you are not trying to show everything, or it will simply be a frustration.

First analyze the shapes, trying to see the colors and main areas of light and shade in blocks to give you a guide for how to begin the painting. Eyesight can make a difference. If you are slightly shortsighted and leave your glasses off to paint a vase of flowers across the room, there will be a natural selection of the things you show, so try to think in this way if you are aiming at a broad statement. But you still need to make sense of it all, so do some close-up sketches first to build your confidence and understanding; the better you understand the shapes and forms, the easier it becomes to simplify them. When you start the painting, keep your distance and start by blocking in the canvas broadly. You can decide on the degree of detail to include as the picture progresses.

If you work in watercolor and are someone who naturally loves detail, but know you will make a better picture by leaving some out, let the "flow" of the paint and the texture of the paper give you a natural guide. Try to imply details without literally describing everything as though you were looking at it under a microscope. Make detailed preliminary studies first, but then try to distance yourself by extracting the essentials. Use a really soft pencil and make a sketch of the whole using as few strokes as possible, almost as though you were doodling.

How medium affects detail

Whether it is watercolor used wet or dry, thick, creamy oils, pastels, or pencils, all media affect the style and message you want to convey. In turn, the character of the medium will affect your control over the work. Experiment to decide which medium suits your aims.

Watercolor: wet To control wet-on-wet watercolor, dampen the paper with clean water in the shape required, and then flood paint onto the designated area. Add deeper hues as it becomes drier, to give definition to the shapes.

Watercolor: dry To increase the depth of watercolor, dry a damp brush on tissue paper. Here, a detailed look has been achieved on a textured surface; the bumps of white paper keep the edges of the petals thin and light.

Acrylic Allows you to apply one color over another so the medium tone decides the overall shape. When building shadows and highlights, apply the deepest and lightest last.

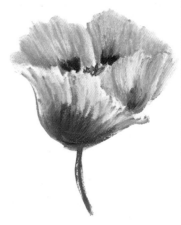

Pastels Pastels can be blended to imply shape, by shading and by the direction of the strokes. You can leave the paper to show through, or layer white over the colors.

How paper affects detail

A smooth surface allows tight brush control, and a rough one makes you use its texture to imply details such as the rough edges of leaves. Lay broad, confident strokes lightly on the surface, to let the paper "sparkle" through. The absorbency rate of the paper also affects how the paint flows, and there is quite a lot of variation between papers.

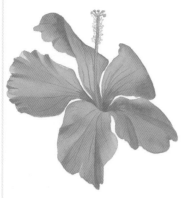

Smooth paper This allows for more drawing with the brush. Remember that not every vein or detail needs to be reproduced to indicate what is happening, the shape and color are often the main attraction.

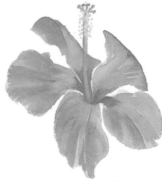

Rough paper Because rough surfaces break up blank areas, use a generous brush full of paint and minimal strokes to establish the shapes of petals. On rough paper, darker tones go in over damp paint easily.

SELF-IMPOSED DISCIPLINE To do detailed work in watercolor you need to use an almost dry brush, so try an alternative approach, working fast with minimum strokes of a well-loaded brush so that your work has a fresh sketchy quality with the paper used to imply texture. A dark, shiny leaf will need more contrasts, evenly and fairly wetly painted, to imply its smoothness. Excess paint can be dabbed off with a tissue or sponge.

If you work in oils or acrylics, try using larger brushes than you would normally choose, and practice suggesting a petal or leaf with just one brushstroke. If the painting looks over-vague, you can add touches of definition in the later stages. Some artists reserve detail for the foreground, leaving the background fairly nebulous and working forward through a fairly well-defined middleground to the main flowers. If you do not want to spend weeks on one painting this is an effective way of producing attractive work. Knowing when to stop is also very important, but this too comes with practice.

MIXED-MEDIA APPROACHES Another method for watercolor painters is to start with washes of the main areas of color and then tighten it up using fine dry-brush work or drawing on top with colored pencil or pen and ink. If you do use dark ink to draw over washes, take care not to make a hard continuous line around every petal, as this has a flattening effect and does not look realistic. Leave the lightest parts alone and indicate just the edges of the petals and leaves where they are most shaded. The paint could even be a little damp when you start the pen work so the lines are softened in places.

The right brush for the job

Although the prime function of the brush is to carry the paint to the canvas it also controls the length of unbroken line by how much pigment it holds and the spread of paint by its width and shape. Practiced handling can imply a lot of detail in just a few strokes.

Fine, continuous lines are easiest to achieve with a small sable brush. When cared for it keeps a firm point and holds a good supply of paint.

Washes and wet-on-wet applications need a thicker, rounded brush that provides a good reservoir of pigment without leaving hard lines.

Flat brushes can be used upright for dabbing, side on for a thin line, or flat on the paper to apply color areas with a definite shape.

Sunflowers and anemones

This subject, which initially appears as nothing but a mass of leaves with a few flowers, could be quite dull if treated in a detailed and strictly naturalistic way, with the flowers completely overwhelmed by the foliage. The red anemones could also become too much of a focal point, the red being complementary to the green. The artist initially saw the sunflowers as the key to her painting, so these and the bright yellow of the cloth were the focus of her thoughts. The cloth does not actually feature in the finished painting, but was very much the inspiration for the yellow background. To get herself going and sort out her ideas she began by making some pencil sketches of the shapes that caught her attention. Then a couple of simple sketches, drawn with a brush, helped her decide what she should include and how to place the subject. Instead of giving the whole mass a central position, she shifted it to one side enabling her to bring in the effect of yellow light.

Preliminary sketches

The artist loves to use color, and making pencil sketches does not come easily to her nature, as it seems an unnecessary delay. However, she recognizes it as a useful discipline, as it familiarizes her with the subject and organizes the composition.

These sketches, made with an HB pencil, were primarily concerned with the main flower and leaf shapes and the fall of the shadows.

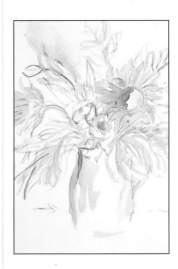

In a further preliminary sketch, color and composition were explored, using a brush filled with the main color. Note that a large proportion of the leaves have already been "edited out," although the most important shapes are indicated.

In the third, very loose, sketch, detail has been further reduced, and all but the salient points edited out. The painting can build from this point.

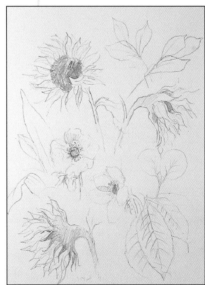

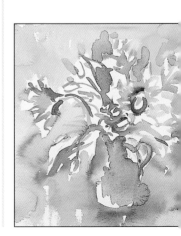

MATERIALS

Tubes of transparent watercolors

300lb smooth watercolor paper

Large soft squirrel and synthetic brushes, with some smaller sable

Salt

Tissues for dabbing out excess moisture

Sharpened twig

COLORS

Cadmium lemon

Cadmium yellow

Indanthrene blue

French ultramarine

Cerulean blue

Green gold

Quinachrodone gold

Brown madder

Winsor red

1 No preliminary pencil drawing is made, as the ideas have been thoroughly worked out in advance. Instead, brushes are used, with the same colors as before, to make an outline sketch. The work is held at a slight angle so that wet-into-wet effects can be encouraged by tipping the board to let the colors run.

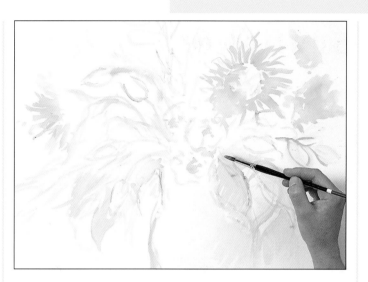

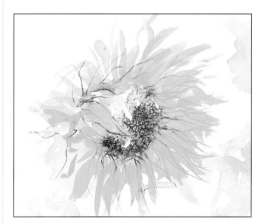

2 The front sunflower is worked up first; this is one of the main focal points of the painting. The outline of the petals were drawn in by using a sharpened twig to drag out lines of paint taken off a brush, and the dappled effect in the center of the flower was created by dropping salt into the wet paint.

3 The artist has decided that the sunflower on the right should be left as it is or it will become too dominant. She now works on the red anemones, which are a natural focal point because of their color and central placing.

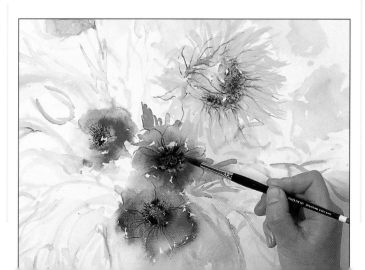

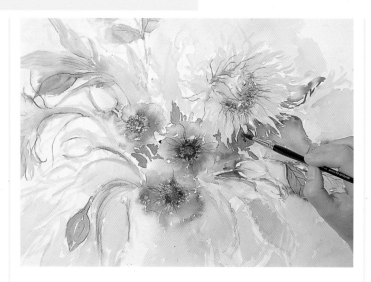

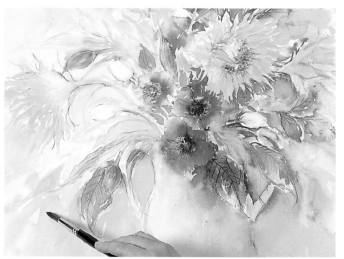

4 Compare the photograph of the set-up and you will see how the mass of leaves is being simplified. Their role is mainly to provide tonal contrast to lift the yellow of the sunflower and give it more importance. The dark green is a mixture of green gold and indanthrene blue; the more sage green comes from using cerulean blue instead.

5 As the color sinks into the paper and begins to dry, it becomes paler, and needs boosting. The whole painting is continually evaluated for tones and strength of color. Attention is now drawn to the white tulips, which compensate for the toning down of the strong shapes of the leaves on the left.

6 The artist now turns her attention to the background, flooding in yellow to suggest sunlight. This background was inspired by the cloth, although the latter plays no part in the composition. The jug has been deliberately left blank to see if any exciting and semi-accidental effects such as backruns occur where the flowers meet.

7 The colors have now reached their final depth. Here a tissue is dabbed into the wet paint to remove a little of the red for this lighter circle around the flower center. The close-up photograph shows how one color has overlapped another, implying there is a lot going on without drawing in every line and leaf.

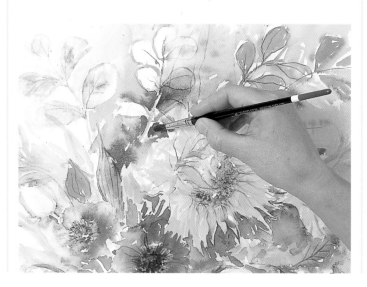

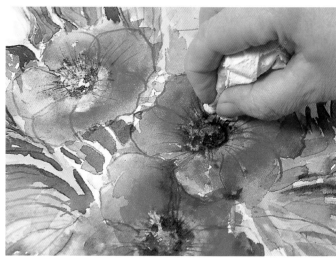

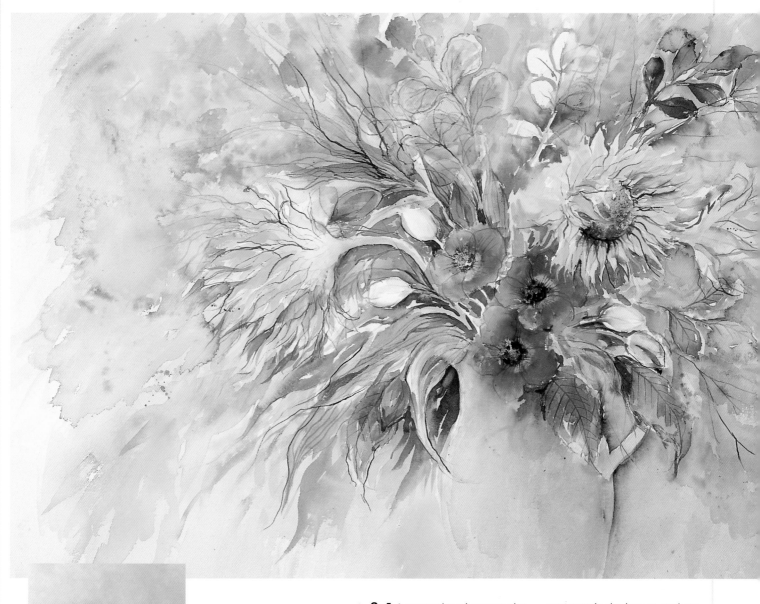

8 | A comparison between the finished painting and the photograph of the set-up shows how the artist has interpreted the subject and taken the elements she wanted. She has played down the tonal contrasts in the leaves, and yet given an accurate impression of the foliage, and she has given the white tulips, almost invisible in the photograph, more importance.

Framing

The practical reasons for framing and glazing a painting are obvious. We want to be able to hang it on the wall to look at it, and we need to protect it from damp and dirt.

Watercolors and pastels should always be protected by glass, and the painting should not come into contact with the glass. If there is no air gap condensation can occur, and this can lead to foxing and other fungal growths. Usually a mat board is used, but if you want to see the picture framed right up to the edge, a thin fillet between the picture and the glass will also serve the same purpose.

There are different types of glass, such as non-reflecting, ultra-violet, and protective. Non-reflective glass can be useful for large botanical studies on a plain background, as these can be quite difficult to see, especially if hung opposite a window. However, this type of glass, as well as being expensive, can obscure detail and change the look of the painting, so consult with the framer, and if possible ask to see something that has already been framed using it.

MATS The color of the mat board should be chosen to complement the painting. The width is optional, and will depend to some extent on how big you want the finished area to be. Small paintings are sometimes mounted, as they can look much more important with space round them. It is normal to have a wider space at the bottom of the mat than at the top and sides, which prevents the optical illusion that the picture is slipping out of the frame. An effective and simple way of adding to the three-dimensional look of a picture is to use a double mat, picking out two main color shades used in the work—say a dark inner with a pale one over. Some double, or even treble, mats have a sculptured look achieved by cutting lines to different levels into the surround. A traditional way of mounting watercolors is to use a very pale colored board and do watercolor wash lines around the inner edge, picking up the colors used in the painting. Some artists paint right over the mat board as well, extending the foliage over the edge. This can be very attractive, but there is a danger of the board deteriorating over the years, losing half the work. Both mat board and backing should be acid-free or it will eventually affect the painting.

The parts of a frame

A frame for a work on paper, such as a watercolor or pastel, consists of the four separate parts shown below. For most frames, $^2/_{25}$ inch glass is used, and the backing board is either masonite or plywood. Oil and acrylic paintings done on canvas do not require either a mat or glass, though they are sometimes framed in the same way as works that are done on paper.

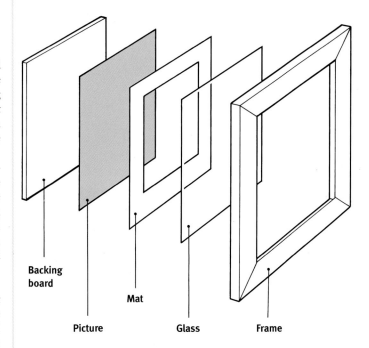

Backing board

Mat

Picture

Glass

Frame

FRAMES Oils and acrylics can be mounted and glazed also, but they do not have to be. Both should be varnished, and oil paintings should be allowed to dry for six months before the final coat of varnish is put on if the paint is at all thick. Canvas needs to be kept stretched and the sides of the painting need protecting when being handled or stored. The stretcher does most of the work, but the frame helps keep this in place, especially when moving or stacking it. Some oil painters use plain wooden frames which they paint so that frame and picture become one entity.

If you are planning an exhibition of your work, use the plainest, cheapest frame that still shows the work to advantage. It must also be strong enough for your painting—if you pick it up by the top you should not be able to feel any give in the frame.

Choice of mat

If you intend to cut your own mat take the picture with you when you buy the board, and try different colors. The neutral colored mat suits the painting more than the red one which, though picking up the color of the flower centers, tends to overpower the image.

Color choices

Mat board is made in a wide variety of colors. The very bright and very dark colors are more suitable for inner mats in a double or triple mat, as they could overwhelm the painting if used over a larger area.

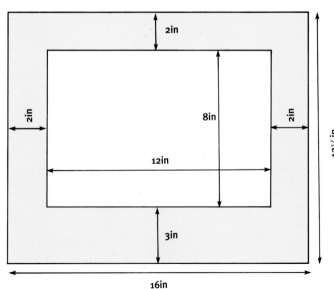

Proportions

When measuring for a mat, allow more depth at the bottom than the top and sides. This is particularly important if the picture is to hang above eye level, as the perspective will make the mat appear thinner at the bottom.

Double and treble mats

Double mats are always advisable for pastels, which must not come in contact with the glass, but can be used for any work on paper. Both treble ❶ and double ❷ mats enhance the work by adding depth, and also allow you to experiment with different color combinations. Usually the inner mats are darker than the outer one.

❶

❷

Cutting a mat frame

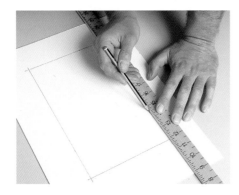

1 Start by putting your picture on the board and moving it around until you find the right width of margin. Cut board to the outside measurement first and then mark measurements for the aperture.

2 Some matcutters are attached to their own rulers (see below left). If you use a different type you will need a good straightedge. Align this with the marks and pull cutter slowly along each one.

3 Before removing the cutout piece, make sure that it is not sticking, or you may tear it. Some cutters go cleanly through the board at one push, but others may take two or three cuts.

Matcutters

It is possible to cut mats with a sharp knife, but it is tricky to bevel the edges evenly, so it is wise to invest in a cutter. This type has a plexiglass base, which allows you to see the line as you cut the bevel. The triangular blades are designed to cut through the board in two or three places.

Oval mats

1 Draw intersecting straight lines. Use nails to mark lines on the longest side. Loop string around the nails. Place a pencil inside the loop, pull tight, and draw the oval.

2 Cut a template from stiff cardboard and nail it in position on the mat-board. The cutter cuts $\frac{1}{32}$ in. from the edge, so the template has been cut that much smaller all around.

3 Carefully cut around the template. Pay attention to the curve at the apex of the oval.

Fixing picture to mat

1 There are two methods of doing this. You can cut another piece of board the same size as the mat and make a sandwich, fixing the picture to the backing piece with small hinges made from gumstrip or masking tape.

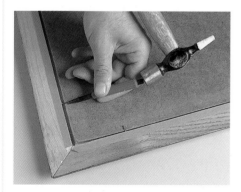

2 Alternatively you can fix the picture directly to the back of the mat. In either case use as little adhesive tape as possible; the backing board and glass will hold the picture firmly in place.

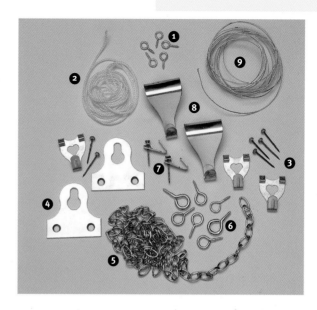

Fixtures

There is a variety of fixtures and hangings. For heavy pictures, mirror plates are safer than screw eyes.

1 Brass screw eyes
2 Nylon cord
3 Picture hooks with pins for invisible hanging
4 Mirror plates
5 Chain, for decorative hanging
6 Chrome screw eyes
7 Single picture hooks and pins
8 Brass picture hooks
9 Picture wire

Securing the frame

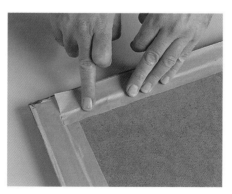

1 When glass, picture, and mat are in place, the backing board is slipped in and secured with panel pins with a punch, as shown.

2 To make the back look neat, and to prevent any moisture seeping in, gumstrip is stuck down around the edges of the backing board.

3 Screw eyes for hanging should be placed approximately a quarter of the way down the frame. Make small pilot holes first with an awl.

THE GALLERY

Look closely at the work of the best exponents of flower painting, and concentrate on seeing how the results are achieved. The following examples have been chosen to show how flowers can be looked at and worked in widely differing ways and using different media, from beautiful botanical studies, awe-inspiring in their detail, through to stylized depictions that rely on glorious color. The inspiration and inventiveness here will make you take another look at the familiar flowers around you.

Creating variety

When you are dealing with an arrangement consisting of only one type of flower, or a mass of flowers of similar shape, you need light and shade to keep the variety alive. But you can also exploit the repetition of shapes and colors, as in these examples, all of which are lively and varied despite the fact that a limited number of colors have been used. Use background foliage to give depth and contrast, or introduce vases or other still-life objects to contrast with the organic forms of the flowers and compensate for any "sameness" in the flower shapes.

▶ STARGAZERS
Shirley Felts
Watercolor

This is painted in a loose but controlled style, with the wet pink paint allowed to "dampen in" to form the soft pattern in the lily petals. The artist has focused in on the nearer lilies, treating those at the edges and in the background with little detail. The smaller vase at the front gives depth and perspective, but has been treated lightly. The calm, rounded shape of the small pot on the right provides an anchor for the profusion of leaves and flowers.

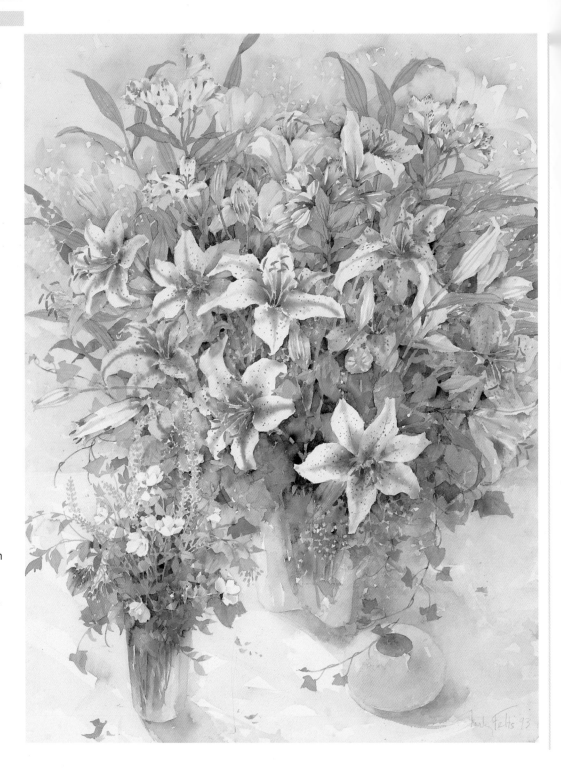

▶ COSMOS
Adelene Fletcher
Gouache and watercolor
These flowers almost jump off the page at you—clean, crisp, and bright. An overall, loose wash was taken around the flowers, which were initially reserved as white paper, and deeper greens built up around them. The fern like foliage is the perfect foil for the firm, clear shapes of the flowers. Notice how the flowers are shown pushed deep into the vase so that they appear firmly "rooted."

◀ VYVYAN PENNELL
Norman Coker
Oils
Though painted in thick oil paint, with touches of impasto on the white flowers, the clematis petals are soft and delicate. A variety of hues, from deep purple to pure white, have been merged wet-in-wet with sure strokes of the brush. Strong tonal and textural contrasts, with the cool, hard surfaces of the glass set against the softness of the flowers, add a further dimension. The bottle and glass also provide some light and further contrast in the intriguing deep shadows.

Single flower studies

These three paintings, all of the iris family, demonstrate the impact that studies of a single bloom can have. The painting of the white iris (right) exploits lighting and cast shadow to achieve an intricate surface pattern. In the painting below right, the purple flowerheads are given emphasis by the way they are arranged against the near-black background, and in the study opposite the tonal structure is reversed, with the petals making strong, dark shapes against a background of virgin white paper.

▶ WET IRIS
Kitty Wallis
Oil
This painting shows how successfully opaque oil paint can evoke the paper-thin quality of petals. Although the blue flowers have a very dark background, they still give the appearance of being in bright sunlight, with crisp, clear shadows and light coming through the petals. The artist began with an underpainting to establish the tonal values and basic areas of color, and then built up the depth of color with both oil bars and oil paint.

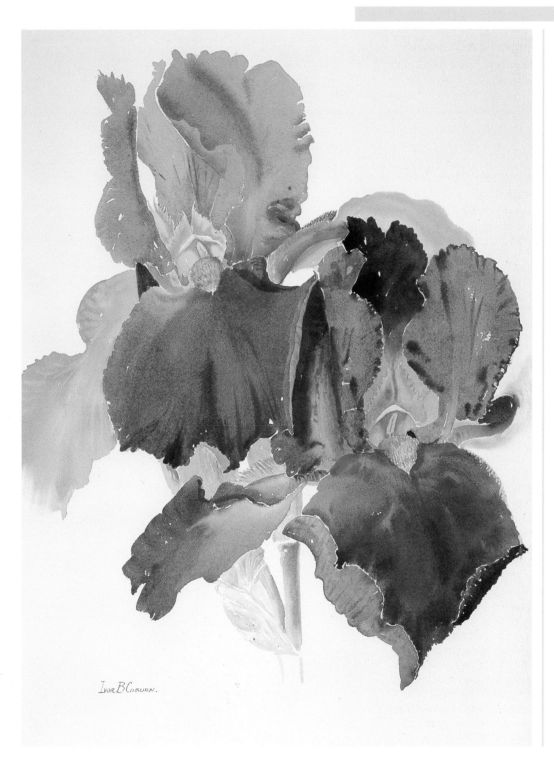

◄ IRIS 'BRIGHT WHITE'
Sally Keir
Gouache
There are no distractions in
this painting, and attention is
concentrated on the bloom
through the dark background
and strong lighting. The
shadows give an exotic and
mysterious atmosphere,
reflecting something unseen
that is happening outside the
picture. The initial drawing was
done using white pencil on
dark green conservation board,
and layers of gouache were
subsequently used to build up
each petal.

▶ IRIS, VITA FIRE
Ivor Coburn
Watercolor
This painting is unusual, as it
is very much larger than life,
measuring around 30 x 22
inches, enabling the artist to
show the full drama of the iris.
The paper was thoroughly
dampened, left for a while,
and then a wide flat, soft
brush of squirrel hair was used
—this type of brush can hold
a large reservoir of paint. In
places a hairdryer was used to
dry out the surface to add
crisp details.

The patterns of leaves

Foliage should never be ignored, though it can be generalized to give more emphasis to the flowers, and leaves are always available, whereas the flowers are seasonal and can be fleeting. These paintings show how exciting pictures can be created giving emphasis to leaves.

▼ POPPY
Don Austen
Acrylic
The leaves are almost cutouts, and the shadows are simplified to exploit the interplay of light and middle tones against a background.

◀ CYCLAMEN GRAECUM
Jenny Brasier
Watercolor
This is a botanical study in which each flower has to be matched with its leaf, but the contrast of shapes and tones is of importance. Details were measured, drawn on sheets of tracing paper, and transferred to smooth-surfaced paper.

▶ GREAT WHITE BIRD
Richard French
Watercolor
This composition is based on the pattern made by the contrasts of tone. The colors are cool, yet implicit of heat. The yellow in the warm light contrasts with the white of the flower. The painting was built up of layers of watercolor.

▶ RAINY DAY
Kitty Wallis
Pastel over acrylic
These leaves give a convincing impression of floating even though we can see through to the supporting stem underneath. The composition echoes the shape of the leaves, making circles within circles. Cotton rag paper was used with a sanded surface, and the artist began with an acrylic underpainting, working into it with expressive, lively pastel marks.

Botanical studies

If you have ambitions toward professional botanical illustration, or simply admire the colors and shapes of flowers and want to engage with them in detail, remember you will need both time and patience. The paintings shown here were the result of several sessions of work, and time spent studying and drawing plants. You also need a medium that can be thinned and controlled, and a smooth surface. Watercolor is the most often used, in the dry-brush method, which involves applying a small amount of paint at a time with a brush that has been lightly dried on a tissue. To help blend the colors, you can wet one area, for example one leaf or petal, float the color onto it, and go over it again when dry to build up darker, richer colors.

Phalaenopsis equestris (Schauer) Rchb.f.

▲ PHALAENOPSIS
EQUESTRIS
CAROL WOODIN
Watercolor
This orchid has beautiful foliage which the artist has made the most of, using successive layered glazes to achieve their glossy, fleshy appearance and their slight mottling. They provide a perfect foil to the mass of small, brilliant flowers, which also have a slightly fleshy look to them. The butterfly adds a decorative touch and gives interest to an area which might have been dull.

▼ SNOWDROP–GALANTHUS NIVALIS
Kristin Jakob
Watercolor
To capture the freshness and elegant simplicity of these snowdrops, the artist has worked fairly fast and has avoided overworking. She has used hot-pressed paper and began with a pencil drawing to outline the flowers. The stems and leaves have been almost drawn also, but in watercolor with a dry brush.

Snowdrop–Galanthus nivalis ©1982 Kristin Jakob

▲ TILLANDSIA CYANEA
Pauline Dean
Watercolor
This is a perfect illustration of dry-brush technique. The artist first made a drawing with a hard pencil (3H) on hot-pressed paper to make faint guide lines, and added color by "drawing" with a brush, making the strokes follow the flowing line of leaves. The placing on the paper gives space for the leaves.

The choice of flower

Why does an artist choose a particular flower to paint? There can be a variety of reasons, reflecting the artist's wider interests. Some will choose for shape, others for color, form, or the patterns they made. In this selection of paintings you can see how the flowers have been used as a starting point for enlarging on an idea or developing a pictorial theme.

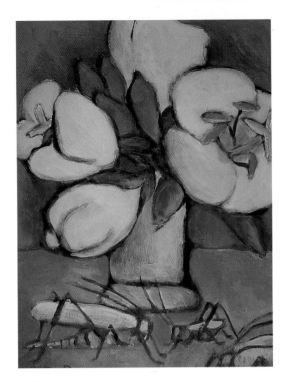

◄ THE GRASSHOPPERS
Gerry Baptist
Acrylic
This artist loves vivid colors, and here has based his painting on the three primary colors—red, yellow, and blue. He achieves intensity of color by building up in successive layers and glazing transparent paint over opaque applications.

◄ FLORAL RHAPSODY
Betty Blevins
Acrylic
Close harmonies of cool colors, combined with the abstract shapes that cut across the flowers in a collage-like effect, give this painting an other-wordly quality. White acrylic paint was used to draw the design onto the paper, a warm underpainting was made, with some areas left white to give different shades to varying blues laid on top.

▲ RED ZINNIA
Elaine Amsterdam-Farley
Watercolor (24" x 18")
If you saw this painting hanging on a wall, you would read it almost as an abstract arrangement of shapes. Painted in transparent watercolor directly onto the pure white ground, it conveys tremendous strength and power.

◀ THE BLUE DOOR
Richard French
Watercolor and gouache
This composition has a powerful vertical emphasis, with the elongated format emphasizing the upward thrust of the plant's strong, straight stem. The blue door, seemingly hanging in space, imports a surreal flavor as well as providing color contrast for the flower.

Floral still-life

Painting indoor flower arrangements in a pot or vase is a branch of still life painting, and can be extended further into this field by including other objects and surfaces. These can complement or contrast with the shapes and colors of flowers and foliage, and also allow you to create more complex or well-balanced compositions and to vary textures and colors. If you are a serious flower painter the objects must not be allowed to steal attention from the flowers; see them as devices to draw the eye to the main focus of attention.

▶ FRENCH COLORS
Janice Drevitson
Pastel
The scalloped and embroidered cloth, arranged to form a triangular shape, provides the perfect balance for the flowers, and the squat pitcher is an ideal shape to contain them. Notice how the artist has echoed colors, using paler versions of the flower colors in the cloth, and repeating yellow from flower centers to background.

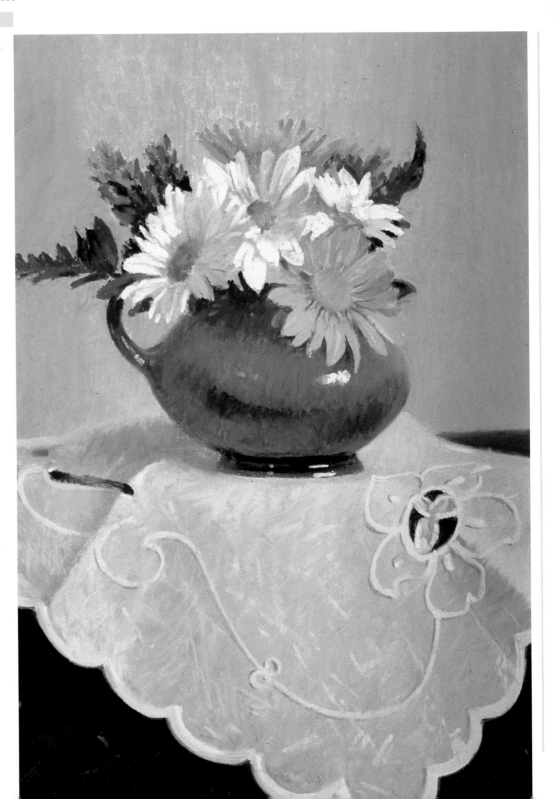

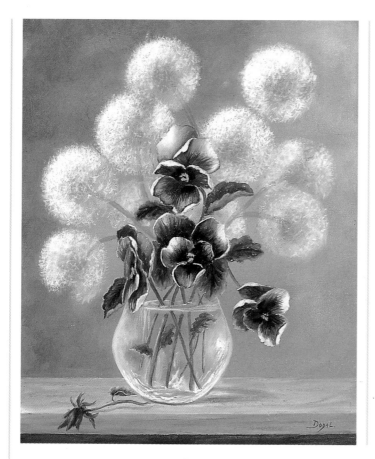

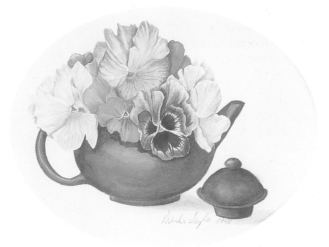

▲ PANSIES IN A POT
Pamela Taylor
Watercolor
This charming little teapot, although an unusual container for flowers, suits them very well. The oval format is also a clever choice. It contains the whole composition without cramping it, and the outer curves echo those of the teapot and lid.

▲ DANDELIONS
Dolya Dogal
Oil
The fallen flower in the foreground breaks the horizontal of the table edge and draws the eye in to the pansies and stems in the vase. The dandelions were "fixed" with hairspray to stop them blowing away, and the dramatic lighting was achieved by putting cardboard around the arrangement. The painting has been built up in layers, from dark to light, and the fragile dandelion clocks painted in with delicate touches of a brush tip.

▶ SUMMER FLOWERS
Pamela Davis
Gouache
This is a carefully worked out composition, with perfect harmony and balance. The small lidded pot overlaps the flower vase, and combines with the artfully arranged folds in the tablecloth to lead the eye in to it. The taller pot provides a balance on the left, and its decoration echoes the flowers. The color scheme is equally controlled, with a harmonious range of pinks and mauves set off against the ocher of the background and gold of the vase.

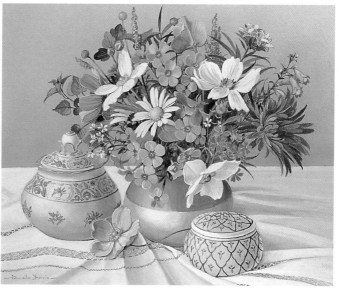

Flowers for their own sake

Whether you choose a sprig or branch or pick flowers from the garden, painting individual pieces exactly as they grow rather than arranged in a vase will give you familiarity with the subject and increase your confidence to tackle anything. To make a serious study, keep a sketchbook for notes on plants that go out of season. Even if you eventually develop a more impressionistic or even non-representational style, time spent learning your subject will never be wasted, and it will help you if you intend to do mixed groups, as you will have a good grasp of the individual plants and flowers.

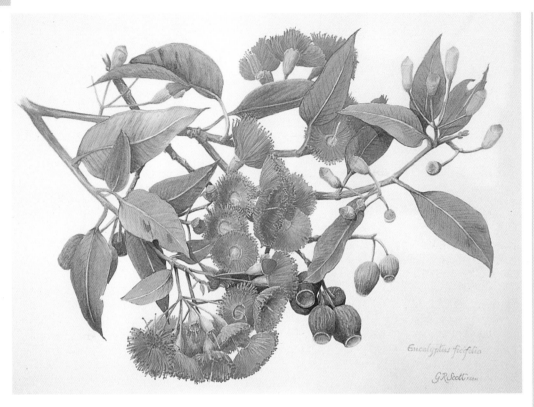

▲ EUCALYPTUS FICIFOLIA
Gillian Scott
Watercolor
The sprig of the fluffy red-flowered eucalyptus is depicted exactly as it would grow, so that it comes into the picture seemingly without interruption. Using transparent watercolors, the artist has created the flowerheads, with their masses of thin petals, by means of directional strokes made with a small brush.

▶ MIXED FLOWERS
Pamela Davis
Acrylic
Knowledge, practice, and technical skill have all come together for this enchanting mixed bouquet. It was painted in acrylic, a medium the artist particularly likes as it dries fast and gives her good control. With the basic composition in mind, she began with the lilies that form the focal point, adding the other flowers in stages.

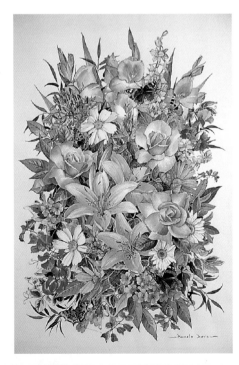

▶ CAMELLIA SASANQUA
Siriol Sherlock
Watercolor and gouache
This is an example of acute observation and excellent drawing and painting skills. The area for the stamens was masked out and each flower was then painted separately, after which the masking was removed and the stamens painted in with opaque gouache over red petals. The leaves and stems were put in after the flowers, using a series of washes, and allowing the white paper to shine through to create the gloss.

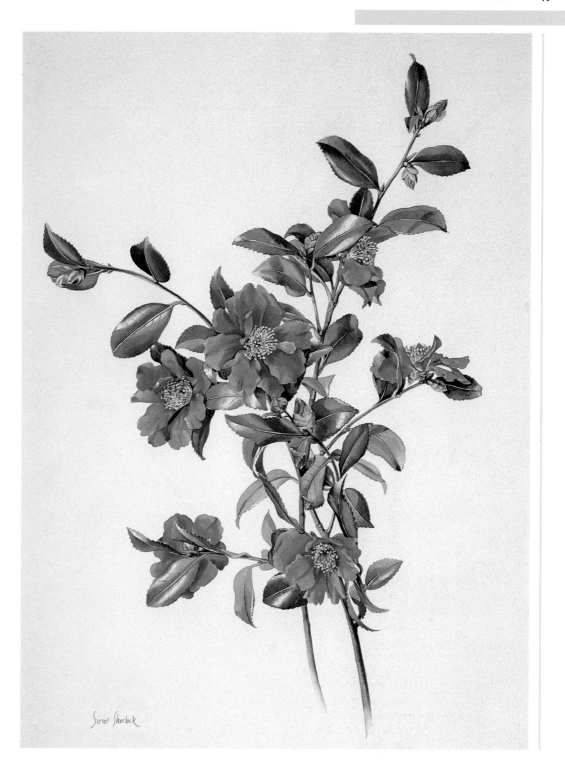

The artist's favorite

Ever since Van Gogh immortalized the sunflower, these have been a favorite with artists, whether painted as single blooms, arranged in vases, or in situ, massed together in fields of glowing yellow. These huge flowerheads do not work well in mixed groups, as they would dwarf everything else, but their strong shapes make them ideal for close-up treatment. On these pages you can see three quite different approaches to this exciting and challenging subject.

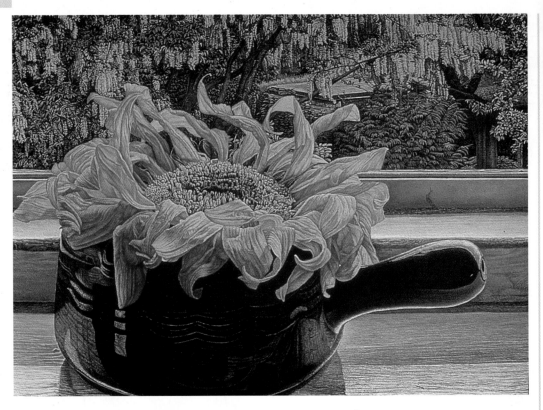

▲ HOMAGE TO A SUNFLOWER
Paul Bartlett
Oil over acrylic
A surreal flavor is imparted by the composition. An acrylic underpainting was finished off in oils, as the artist prefers the "stay wet" quality for mixing.

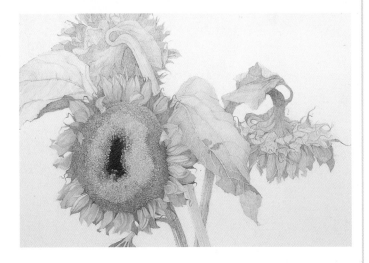

▶ SUNFLOWER (DETAIL)
Vicky Cox
Colored pencil
Considerable depth of color can be achieved by layering with colored pencil. Two neutral shades, gray-green and violet, were used to block in the shapes and forms, and the colors deepened by going over the area again and again, but not to make hard lines.

▶ SUNFLOWERS WITH LEMON
Maureen Jordan
Pastel and acrylic
The yellow of the flowers contrasts with the cool blues and greens, and the warmth of sunlight. Blocking in with hard pastel with alternating acrylic and pastel areas.

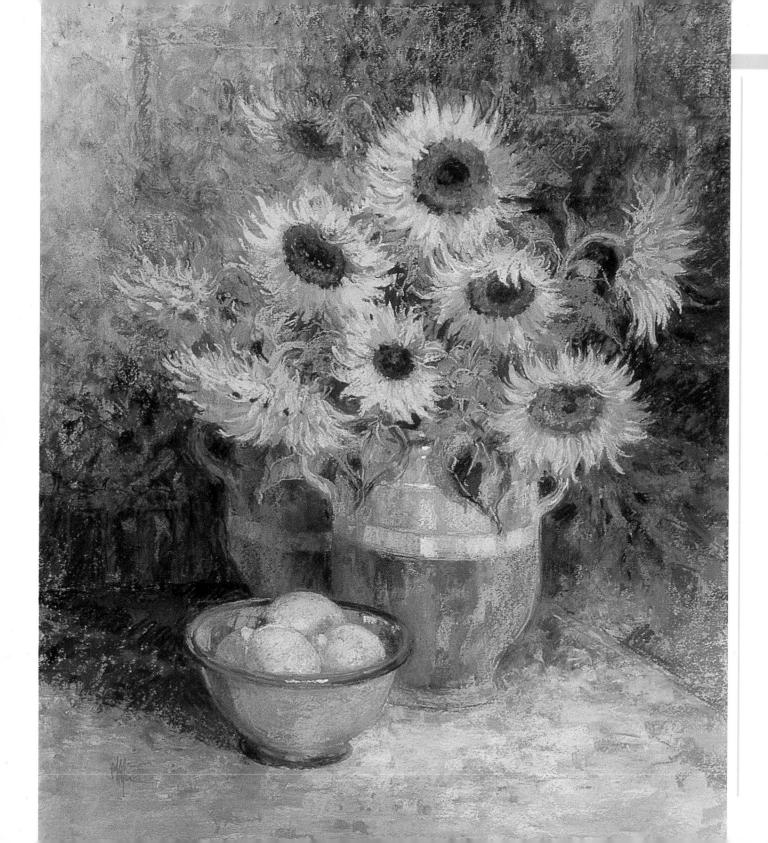

White on white

To paint white flowers successfully it is essential to use tonal gradations to show the edges, but at the same time not to overdo them or you may lose the whiteness. Painting white is a very good learning exercise in any medium, but an especial test of skill in watercolor, as you must leave the white of the paper completely untouched for the highlights. Oils, acrylics, and pastels are opaque, so you can work up to the highlights, and if you make a mistake it is easier to correct—you can even put the painting aside for a few days and come back to it. For watercolor work, be sure to plan before you start to paint, and work out where the highlights are to be. Use masking fluid to reserve the lightest areas.

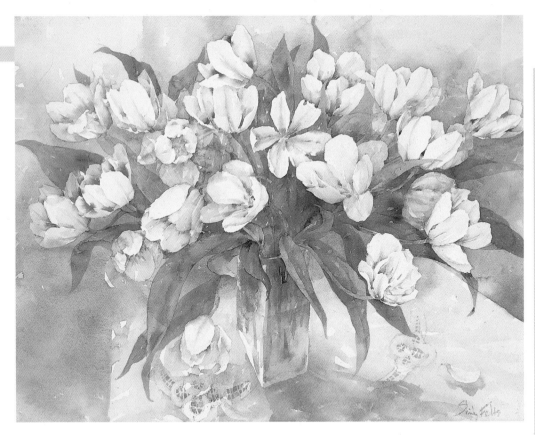

▲ WHITE TULIPS
Shirley Felts
Watercolor
Look closely and you will see that only very small areas of the flowers are pure white. Very pale gray and mauve-gray washes have been laid on most of the petals, and quite dark blue-grays and browns at the bases and where shadows are cast on one petal by another.

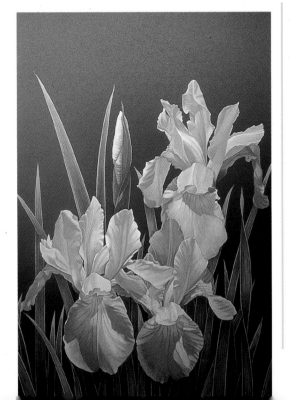

▶ IRIS SIBIRICA-ALBA
Sally Keir
Gouache
The deep green background has allowed the artist to use relatively dark colors for the "whites," yet they still read as white. The work was first laid out in white pencil and white drawing ink and then built up with layers of gouache. The edges were kept clean and crisp so that the petals appear paper thin.

◀ ORCHID, PHALAENOPSIS
Pamela Taylor
Watercolor
This is the perfect example of describing flowers through subtle use of shadows, with no dark background to help define them. Notice that there are small lines of shadow at the edges of the petals, where they curve away from the light. The plant was first drawn lightly in pencil, and color applied in pale washes and dry-brush work.

▶ MAGNOLIA
Dolya Dogal
Oil
These magnolias have been treated in an almost sculptural way which suits the strong structure of the flowerheads. The effect is stressed by placing them on marble—they could almost have been carved from the same material.

Taking it a step further

Flowers can be a symbolic element in a painting, or they can be used to create atmosphere in a painting in which they are not the main focus. You can also combine flowers from different seasons and regions in works that largely spring from the imagination. Keeping a sketchbook or a photographic reference file is essential, as it could take several seasons to collect all the subjects.

▲ PERFECT BLOOMS
Paul Bartlett
Colored pencil
The full title of this painting is "Perfect Blooms, Rotten Apples, and a Glimpse of Something Beyond," which gives us a clue about the artist's intentions. The cactus, apple, and withered stems seem to be interlopers among the soft summer flowers.

◄ FLOWERS AND LACE
Betty Carr
Watercolor
There is a lot going on in this painting, creating an attractive feeling of life and movement. It is saved from looking over-cluttered by the geometric framework of the window and shutters and the regimented diagonal line of the three containers.

◀ PARROT ON URN
Barbara Valentine
Watercolor
Every element in this painting carries a message or tells a story, but the blue bird is the main symbol. This is the bird of happiness—one may search far and wide for it but it is always found in one's own garden. The main design was worked out in sketches and then transferred freehand as a brush drawing in a pale neutral color. The flowers and other objects were then added, and the colors gradually worked up.

▶ STILL LIFE WITH ROSES
Denise Burns
Oil
Here the pitcher of garden roses emphasizes the atmosphere of this cottagey interior lit by warm, pink light. It is obviously a time of plenty, with the summer fruit scattered and the roses in full bloom. The oil paint has been used at a thick and creamy consistency, with the colors mixed and blended wet-in-wet and layered to give additional depth and vibrancy.

Moving outside

Painting flowers out of doors is both rewarding and challenging. It is a pleasant way to spend time, but you will have to cope with changing light, and thus work fast or in a series of sessions at the same time of day. If you do the latter, the flowers will have changed, so one solution might be to start on the spot, take photographs or make notes, and finish indoors. For initial attempts, choose a medium that allows you to work quickly—watercolor, pastel, or acrylic would all be suitable—and see how much you can get down in two or three hours.

▶ GARDEN PATTERNS
Denise Burns
Oil

A human figure tends to be the natural focal point of a picture, and the artist has recognized this, treating the flowers in broad, general terms so that they do not claim too much attention. Notice how cleverly she has used brushmarks to suggest the shapes and growth habits of the flowers and leaves.

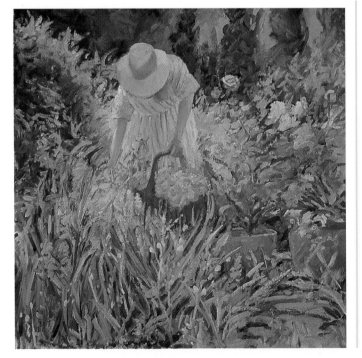

▲ TULIPS AND LILIES
Joan Roche
Watercolor

The stripes cast on the paving stones illustrate the exciting effect shadows can have, and how they can form an important element in the composition. Here they provide a perfect balance for the verticals of the narcissus leaves. This was worked in transparent watercolor, in a combination of wet-in-wet and wet-on-dry methods. It was painted rapidly and with confidence, giving it a clean freshness.

▼ A POT OF GERANIUMS
AND FUCHSIAS
Maureen Jordan
Pastel
The artist has focused on the
group of flowers in their blue
tub. But the garden setting has
given her the opportunity to
exploit both the pattern of
leaves and the texture of the
foreground flagstones.

▲ SOUTHWEST GARDEN
Betty Blevins
Watercolor
This is a marvelous example of
the use of shadows, which
probably inspired the artist at
least as much as the flowers.
The geranium lying on the
ground, however, points out
their importance and forms a
visual link between foreground
and middleground.

Index

Page numbers in *italics* refer to illustrations

Credits

We would like to thank and acknowledge all the artists who have kindly allowed us to reproduce their work in this book. We would also like to thank in particular those artists who demonstrated specific techniques.

Picture credits

Nedra Tornay p.2. Royal Botanical Gardens Kew p.7. Harry Smith Horticultural Photographic Collection pp.53 (top right), 89 (bottom left).

Artwork credits

Mike Bernard pp.57 (right), 60–61, 63 (left), 64–65, 81 (right), 88–89. Sébastien Bertrand (backgrounds). Sally Bond pp.35 (right), 92–93 (left). Rima Bray p.25. Geraldine Buffery pp.48–49, 120–123. Pip Carpenter pp.63 (right), 80 (right), 115–117. Libby Carreck pp.58–59, 76–77, 96–97, 124–125. Rosalind Cuthbert pp.57 (left), 62 (top), 68 (right), 90–91, 92 (right), 98 (right), 99 (left), 102 (left), 103 (top), 107 (bottom), 108 (bottom right). Elizabeth Harden pp.56 (top), 62 (bottom), 68 (left), 74, 80 (left), 86 (top), 87 (left), 93 (top), 98 (left). Hazel Harrison p.75 (top). Christine Hart-Davies pp.56 (bottom), 75 (bottom). Jane Hughes pp.54–55. Dave Kemp pp.43, 131. Sally Launder pp.10–11. Judy Linnell pp.66–67, 105 (all), 106 (bottom), 109, 126–129. Kay Mullen p.6. Alan Oliver pp.69 (right), 72–73, 78–79, 86 (bottom), 94–95, 99 (right), 102 (left), 103 (top), 104 (left), 106 (top), 108 (bottom left). Ian Sidaway pp.28–33. Catherine Slade pp.52–53, 70–71, 82–83, 84–85, 100, 101, 107 (top). Elizabeth Smail pp.81 (left), 93 (bottom). Pam Taylor pp.38–43, 120–123. Richard Tratt pp.1, 69 (left), 87 (right).

Photography

Martin Norris, Paul Forrester, Laura Wickenden, Chas Wilder.

Senior Editor Kate Kirby
Editors Hazel Harrison, Ian Kearey, Jean Coppendale
Art editor Sally Bond
Designer James Lawrence
Picture researcher Miriam Hyman
Indexer Dorothy Frame
Assistant art director Penny Cobb
Art director Moira Clinch
Editorial director Pippa Rubinstein